Neo-Impressionism

Artists on the Edge

This catalogue was produced in conjunction with
the exhibition *Neo-Impressionism: Artists on the Edge*,
which was organized by the Portland Museum of Art
and presented June 27 through October 20, 2002.

The Portland Museum of Art gratefully acknowledges
Scott and Isabelle Black, whose leadership and support
have made this exhibition possible.

This exhibition has been generously sponsored
by Peoples Heritage Bank.

Media support has been provided by WCSH 6 and
the Portland Press Herald/Maine Sunday Telegram.

Edited by Fronia W. Simpson

Designed by Karin Lundgren

Printed by Penmor Lithographers, Lewiston, Maine

Published by the Portland Museum of Art,
Seven Congress Square, Portland, ME 04101

Library of Congress Control Number: 2002104150

ISBN: 0-916857-30-1

Cover:
Paul Signac, *Port of Saint-Cast,
Opus 209,* 1890, oil on canvas,
26 x 32½ inches, Museum of
Fine Arts, Boston, Gift of
William A. Coolidge, 1991.584

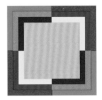

Contents

Sponsor's Statement

Three years have elapsed since the last French painting retrospective at the Portland Museum of Art. During this period, my mother, Selma Black, an avid art lover and connoisseur, passed away. While she always acknowledged that my best painting was the Edgar Degas *Pagans et le Père Degas*, her favorite work in my collection was *La Régate* by Théo van Rysselberghe. The rippling waves, dazzling light, pleasure sailboats, and rockbound coast echoed her lifelong delight in the natural beauty of the Maine coastline.

Reminiscing about my incipient auction experience at Sotheby's in May, 1985, I rediscovered that the first painting which I pursued was Paul Signac's *Route de Cap Antibes, Le Soir* (1903), an aesthetically pleasing landscape. Having visited the Côte d'Azur nearly every summer since 1976, I was intimately familiar with Signac's vantage point in executing this work but was woefully unknowledgeable of his contributions to the divisionist movement. Unfamiliar with the nuances of the auction process, I bid at the high end of the catalogue estimate ($180,000), but lost to a more aggressive buyer. Ironically, I purchased a similar view of Antibes by Henri-Edmond Cross at Sotheby's in 1995. Today, I realize that, from a historical standpoint, both Signac and Cross reprised the 1888 tableaux of the Impressionist master Claude Monet. Signac's framing of the old fort under an overhanging branch was derived from Monet's La Salis series.

Neo-Impressionism: Artists on the Edge is an appropriate title for this exhibition. While the Impressionists had rebelled against the strictures of the official Salon and had ushered in modern painting, Seurat represented a radical departure from the Impressionists' painting the flickering light of nature with comma brushstrokes. Conventional scholarship indicates that Seurat was influenced by the scientific discoveries of optics by Chevreul and Rood. More recently, art historians have opined that Seurat was more interested in creating a harmony of colors in his oeuvre. Like Cézanne, Seurat attempted to make something more solid than Impressionism. Indeed, Seurat was an important innovator: (i) Commencing with *A Sunday on La Grande Jatte–1884* (1884–86), Seurat moved away from nature toward abstraction; (ii) After nearly four hundred years of artists' mimicking of traditional Italianate perspective and vanishing point theories, Seurat changed the pictorial space with multiple vanishing points.

Many art scholars aver that Neo-Impressionism formally ended with Seurat's death in 1891. This assertion is particularly unfair to Paul Signac. First, Signac befriended and

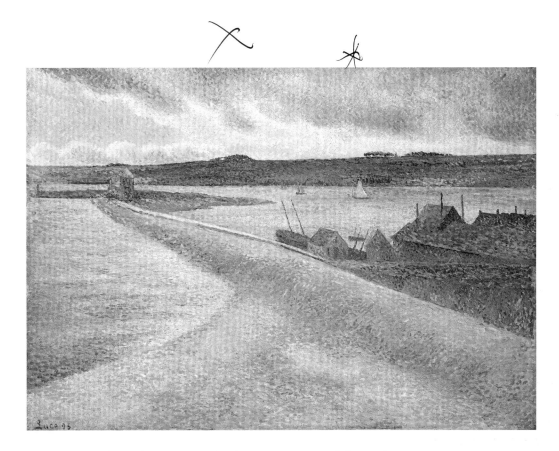

Fig. 1.
Maximilien Luce, *Camaret,
la digue (The Breakwater at
Camaret)*, 1895, oil on canvas,
25⅝ x 36¼ inches, Scott M.
Black Collection

worked directly with Seurat in the formative years of the mid-1880s. More important, after Seurat's death, Signac became head of the Society of Independent Artists, nurturing many future luminaries and inculcating them with the precepts of divisionism. For example, in the summer of 1904, Matisse journeyed to Saint-Tropez to study with Signac. Upon his return to Paris, Matisse produced the early masterpiece, *Luxe, Calme et Volupté*. The following summer, Matisse and Derain painted together in Collioure incorporating hot colors with divisionist brushstrokes, therein launching the Fauve movement. Concomitantly, Braque utilized divisionist techniques in his Fauve renderings of Antwerp and L'Estaque. More than a decade later, the influence of Neo-Impressionism was extant as Picasso and Braque frequently employed pointillist stippling in their Synthetic Cubist paintings.

It is with great pleasure that my wife, Isabelle, and I sponsor this wonderful exhibition. We dedicate this summer's retrospective to the memory of my mother. Throughout her life, she particularly enjoyed Seurat and his circle of friends. Fortuitously, Mom spent many happy moments in France with my sister and me traversing the route of the Neo-Impressionists in Normandy, Provence, and along the Côte d'Azur. Most important, she would have been pleased that the people of Maine have been afforded an opportunity to view so many outstanding paintings at the Portland Museum of Art.

Scott M. Black
May 5, 2002

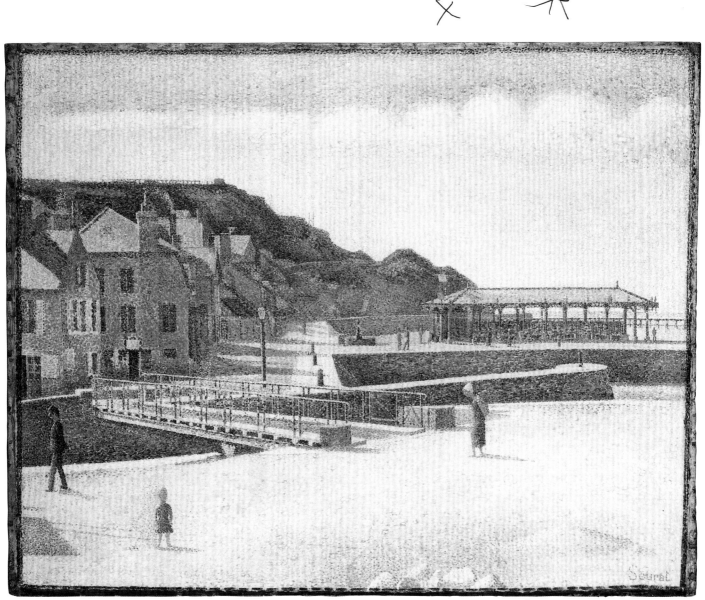

Fig. 2.
Georges Seurat, *Harbour and Quays at Port-en-Bessin*, 1888, oil on canvas, 26 x 32¾ inches, Lent by The Minneapolis Institute of Arts, The William Hood Dunwoody Fund

Director's Foreword

The premise underlying *Neo-Impressionism: Artists on the Edge* is twofold: to offer a public exhibition of Neo-Impressionist paintings for the first time in Maine's history, and to provide a conceptual framework that allows individual scholars to respond to Neo-Impressionist paintings as their personal areas of interest dictate.

In the spirit of Neo-Impressionism, which linked the traditional with the new, the essays in this exhibition catalogue offer a rich range of ideas. For readers wishing to learn more about the artists and works represented in the exhibition, Carrie Haslett's essay, an overview, will be of interest. Haslett, the Museum's Joan Whitney Payson Curator, has used the "on the edge" concept to unify her discussion of this multifaceted artistic movement. For readers already familiar with Neo-Impressionism, essays by Michael Marlais, James M. Gillespie Professor of Art at Colby College, and Sabrina DeTurk, Assistant Provost at La Salle University, offer fresh perspectives and new insights. Marlais's essay examines the notion of a decorative aesthetic among Neo-Impressionist artists, linking it to the influential Pierre Puvis de Chavannes and to Art Nouveau, thereby situating Neo-Impressionism "on the edge" of contemporaneous aesthetic currents. DeTurk's essay brings Neo-Impressionist concerns to the twenty-first century by comparing certain underlying premises, as well as the critical reception, of Neo-Impressionism with another scientifically based artistic approach, digital imaging. In this way Neo-Impressionism may be seen as "on the edge" of the new and digital imaging "on the edge" of the past. Both essays allow the reader to see Neo-Impressionism as they probably never have before.

This exhibition honors the life of Selma W. Black, one of Maine's most effective advocates for education, rights of the elderly, and social change, and the mother of collector, lender to the exhibition, and Museum trustee Scott M. Black. Selma was one of Maine's most loved and admired citizens, and this exhibition provides the opportunity to celebrate her unique qualities and achievements. We are honored to host this exhibition in her memory.

Daniel E. O'Leary

Acknowledgments

We are most grateful to the many institutions and individuals who have lent so generously to this endeavor. For their support in locating and securing loans and information for the exhibition, I would like to express my sincere appreciation to Charlton Ames, Susan Anderson, Scott M. Black, David Brennamen, Karin Breuer, Philip Conisbee, Alexandra Ames Lawrence, Ellen Wardwell Lee, Achim Moeller, David Norman, Joanne and John Payson, Sue Welsh Reed, William Robinson, George Shackelford, Roger Ward, and Elizabeth Ziegler. A special word of thanks to Walter F. Brown, Sr., for his spectacular loan of ten paintings, and to his daughter, Janet, who so diligently gathered and shared information on these works. These paintings enrich the exhibition immeasurably.

My gratitude as well to essayists Michael Marlais and Sabrina DeTurk, each of whom creatively and enthusiastically responded to the conceptual framework of "on the edge." Their contributions are invaluable and make for interesting reading. Fronia W. Simpson and Karin Lundgren made this catalogue a pleasure to develop. A sincere thanks to Fronia for her insightful editing and to Karin for her innovative design.

PMA staff members, past and present, have offered support and assistance on this project as well and to them I express my thanks: Daniel O'Leary, Jessica Nicoll, Aprile Gallant, Gregory Welch, Stuart Hunter, Ellie Vuilleumier, Allyson Humphrey, Rhonda Mottin, Sarah Chase, Kristen Levesque, and Teresa Lagrange. Jessica Routhier and Kathy Bouchard deserve special words of appreciation, Jessica for her travel related to this project, and Kathy for her extensive administrative assistance.

Finally, all of us at the PMA would like to thank Scott and Isabelle Black for their generous support. The continuing presence of their extraordinary collection at the PMA, with its great examples of Neo-Impressionism, provided a compelling force that guided this exhibition.

On a personal note, I would like to thank Tim Bodzioney for his support during the long planning of this exhibition.

Carrie Haslett
Joan Whitney Payson Curator

Lenders to the Exhibition

Anonymous
Scott M. Black Collection
Walter F. Brown Collection
Chrysler Museum of Art
Davis Museum and Cultural Center, Wellesley College
The Dixon Gallery and Gardens
Fine Arts Museums of San Francisco
Fogg Art Museum, Harvard University Art Museums
The Gemeentemuseum Den Haag, The Hague, The Netherlands
High Museum of Art
Indianapolis Museum of Art
The Metropolitan Museum of Art, New York
The Minneapolis Institute of Arts
Museum of Fine Arts, Boston
Museum of Fine Arts, Springfield, Massachusetts
The Museum of Modern Art, New York
National Gallery of Art, Washington
Norton Museum of Art, West Palm Beach, Florida
Mr. and Mrs. John Whitney Payson
Toledo Museum of Art
University of Michigan Museum of Art
The Whitehead Collection, courtesy of Achim Moeller Fine Art, New York

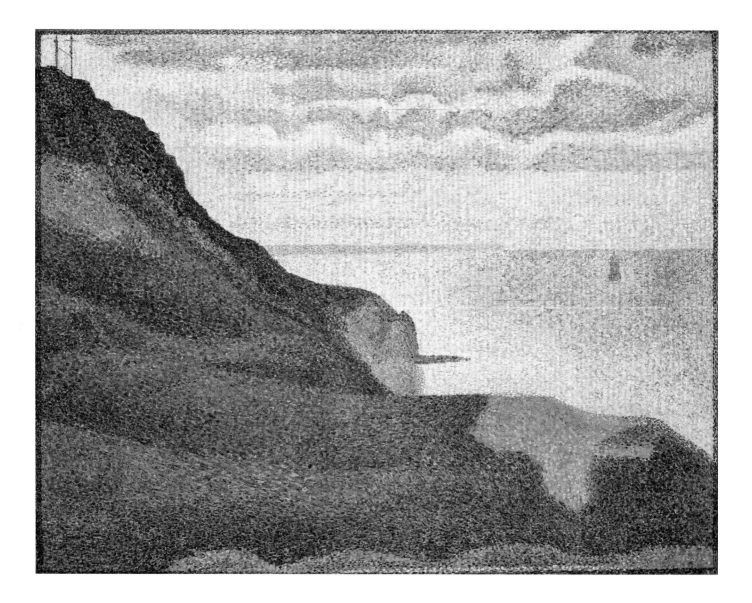

Fig. 3.
Georges Seurat, *Seascape at Port-en-Bessin, Normandy*, 1888, oil on canvas, 25⅝ x 31⅞ inches, National Gallery of Art, Washington, Gift of the W. Averell Harriman Foundation in memory of Marie N. Harriman, 1972.9.21

Neo-Impressionism: Artists on the Edge

Carrie Haslett

This essay offers a chronological overview of the art that is included in the exhibition *Neo-Impressionism: Artists on the Edge* and is intended both to celebrate this particular grouping of objects and to suggest a variety of ways in which to approach these works, individually and as a group. It may be surprising for readers to discover, as this essay will demonstrate, that even so relatively small a gathering of works can convey a sense of the rich diversity of this complex movement, with its wide array of practitioners working over several generations, in different countries, and in ever changing personalized styles and techniques.

In keeping with the other essayists, I will use the "on the edge" concept as a guiding motif for my discussion, reflecting on a number of ways in which Neo-Impressionism may be seen to be "on the edge." Neo-Impressionism was "on the edge" of a host of aesthetic interests of the late nineteenth and early twentieth centuries—Impressionism, Art Nouveau, Symbolism, and Fauvism, among others—and engaged with the most radical thinking of the day. Selected works in the exhibition, as well as the exhibition title, highlight this phenomenon, while underscoring the degree to which waterfront scenes and water emerged as a vehicle for expressing a wide range of ideas. It will become evident that riverside and seashore scenes—places with defined edges between different substances—were dominant settings for Neo-Impressionist artists who used them as loci for exploring activities of manual labor and the political status of the worker, the hedonistic nature of recreational pleasure, and the sheer optical splendor of the illuminated surfaces of water. Each of the major Neo-Impressionists—Georges Seurat, Paul Signac, Henri-Edmond Cross, Maximilien Luce, and Théo van Rysselberghe—explored one or more of these themes, sometimes to the point of obsession.

In addition, the majority of the Neo-Impressionists shared leftist sociopolitical

leanings, which were echoed covertly and overtly in many of their paintings; these sometimes extreme political views may be considered another "on the edge" motif. Still another edge that will be considered is how various paintings in this exhibition push the very limits of representationalism, whether exploring highly fantastical or imaginary subjects or rendering the observed world in ways that are nearly unrecognizable.

Beginnings: Georges Seurat and Early Exponents

The earliest paintings included in *Neo-Impressionism: Artists on the Edge* date to about 1886, the year that Seurat (1859–1891) exhibited his famous *A Sunday on La Grande Jatte–1884* (see fig. 49) in the final Impressionist exhibition. Seurat had developed a new conceptual and technical approach, which incorporated contemporary scientific, optical, and eventually psychological theories in an attempt to create paintings that captured the highest degree of luminosity. Using unblended spectral pigments placed methodically and uniformly onto the canvas, he hoped his paintings would resemble the appearance of real light and color. He chose not to blend the colors physically,[1] believing that the eye would optically "mix" the juxtaposed hues, eliciting intermediate colors in the viewer's perception. Seurat called his new approach "chromo-luminarism," but the term *Neo-Impressionism*, coined by the critic Félix Fénéon in 1886, became its official label. The approach is also known as *pointillism*, a term its practitioners disliked but which refers to the application of paint in small dots, and also as *divisionism*, which refers to using separated strokes of pigment, rather than color blended on the palette.

Seurat had first pointed to this new approach in May 1884, with the exhibition at the Société des Artistes Indépendants of *Bathers at Asnières* (The National Gallery, London), but while his influence was immediately felt by others, it was not uniformly absorbed in its totality. Hence Signac's (1863–1935) *View of the Seine at Herblay* (fig. 4) and Claude-Émile Schuffenecker's (1851–1934) *Maison bretonne dominant la mer* (*Breton House Overlooking the Sea*) (fig. 5), both from circa 1886, reveal two artists straddling Impressionist and Neo-Impressionist aesthetic concerns.[2] Like Impressionist artists, Neo-Impressionist artists chose contemporary subjects, often set outdoors, and attempted to capture the light and color of a given time and place; but while Impressionists emphasized the ephemeral nature of these qualities and hoped to convey such fleetingness through a seemingly spontaneous technique, Neo-Impressionists sought permanence and solidity through a technique based on scientific principles. In these two seascapes the artists deliberately used complementary color pairings and evidenced greater interest in simplification and surface patterning than is typical of Impressionist works, but neither artist incorporated Seurat's pervasive use of complementary color pairings in juxtaposed areas or his technique of applying paint in uniform and precise dots. Although Schuffenecker quickly abandoned the painstaking Neo-Impressionist technique, Signac explored these principles for the rest of his life.

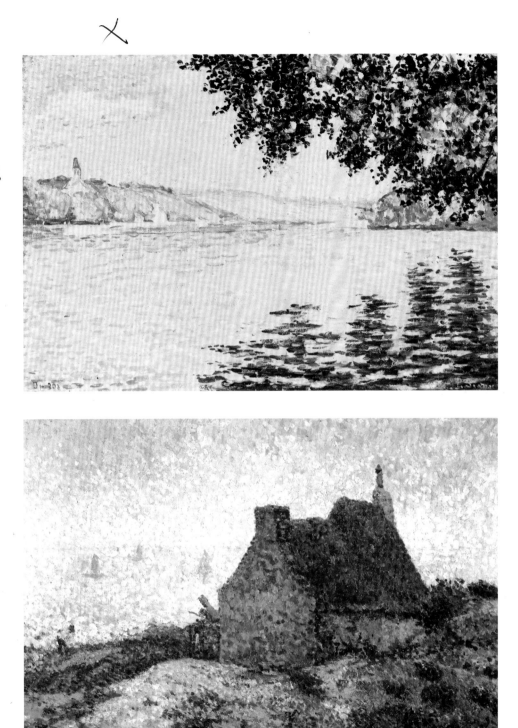

Fig. 4.
Paul Signac, *View of the Seine at Herblay, Opus 203*, late 1880s, oil on canvas, 13⅛ x 18¼ inches, Museum of Fine Arts, Boston, Gift of Julia Appleton Bird, 1980.367

Fig. 5.
Claude-Émile Schuffenecker, *Maison bretonne dominant la mer (Breton House Overlooking the Sea)*, 1886, oil on canvas, 19⅞ x 24¼ inches, Walter F. Brown Collection

Another early convert to Neo-Impressionism was the career military man and self-taught artist Albert Dubois-Pillet (1846–1890), who is represented here by the marvelous tondo, or circular painting, *Sous la lampe (Under the Lamp)* (see fig. 31). This painting was shown in the 1888 Indépendants exhibition to great notoriety. Fénéon, who otherwise was an ardent defender of Neo-Impressionism, harshly objected to its violet-colored frame, executed in a pointillist style, which served as a halo to enhance the coloring on the canvas. He believed that the frame itself should have no meaning.[3] Dubois-Pillet's life and career were cut short by his death from smallpox.

At the same moment that Signac, Dubois-Pillet, and others selectively adopted various aspects of Neo-Impressionism, Seurat continued to develop his personal aesthetic. *Harbour and Quays at Port-en-Bessin* (see fig. 2) and *Seascape at Port-en-Bessin, Normandy* (fig. 3) are two of six paintings that Seurat began while visiting the coastal town of Port-en-Bessin in Normandy in the summer of 1888. Three of these paintings depict views from the cliffs, while the others are centered within the port. Collectively the six show various times of day and both high and low tides.[4] *Harbour and Quays at Port-en-Bessin* is the only Port-en-Bessin painting that includes figures, the three principals being characterized in 1889 by Fénéon as a "stray child," a "distracted customs officer," and a "woman carrying firewood or seaweed."[5] The painting also includes a border, or edge, that has been painted directly on the canvas (rather than on an interior wood frame), a practice the artist began only about 1888. It has been suggested that the edging imitates the shadows the frame would cast if the light source fell from an angle above and from a distance.[6] To create the overall composition in *Harbour and Quays at Port-en-Bessin*, the artist used complementary pairings of green and red (in the cliffs and fish market) as well as yellow and violet (in the land and sky), resulting in tangible three-dimensional structures, recession into space, and relatively voluminous figures, a physicality that was soon made secondary to Seurat's interest in two-dimensional patterning and decorative effect. Though the third dimension is well acknowledged here, Seurat created a strange tension with it through the inclusion of many systematized elements (in addition to the highly mechanized technique of dotting on color)—precise horizontal and vertical lines throughout, artificially stiff figures, the painted border, and an eerie, inhuman stillness. Seurat's paintings were, and continue to be, described as permanent or timeless, and as revealing an order underlying surface appearances, qualities that may be interpreted as looking back to ancient art and to his contemporaries involved with the emerging Symbolist movement.[7]

In contrast to the crisp, cool tone of *Harbour and Quays at Port-en-Bessin*, Seurat's *Seascape at Port-en-Bessin, Normandy* offers a lush color-laden view out to sea from the cliffs. The verdant, light-dappled grass covering the large expanse of undulating cliffs contrasts strikingly with the almost scrimlike flatness of the sea, sky, and boat. Again, the artist created a dynamic surface tension, setting the physicality and palpability of one half of the composition against the more artificial patterning of the second. The painting grows more interesting the longer one looks at it, as the apparently tangible cliffs reveal

subtle areas of flat patterning (such as the large area of broken light to the right and the arabesques along the bottom edge), while the lighting of the clouds and water appears more and more to illuminate a naturalistic recession into space.

The Early 1890s: Seurat's Death and a New Generation Led by Signac

The impulse toward increasing abstraction through the flattening of forms and surface patterning is evidenced in this exhibition to an even greater degree in several exquisite works dating to 1889 and 1890, and it continues to develop over the next two decades in new and sometimes surprising ways by artists espousing a connection to Neo-Impressionism. Signac's two paintings *The Jetty at Cassis* (fig. 6), of 1889, and *Port of Saint-Cast, Opus 209* (see cover), of 1890, demonstrate a marked change in approach and execution from the artist's works of the mid-1880s. This change is heralded by the titles, which now include opus numbers.[8] Identifying artistic productions in this way— a practice common among composers of music—reflects Signac's growing interest in the aesthetic theories of Charles Henry, a chemist and librarian whom Signac and Seurat had met in 1886 (in 1888 and 1889 Signac illustrated posters and illustrations for Henry's books and lectures). Henry's studies asserted harmonic and rhythmic analogies between music and painting.[9] In adopting opus numbers and thereby linking music and painting, Signac emphasized the formal elements of painting (such as line and color) over subject matter. Moreover, Signac's precise rendering of vertical and horizontal compositional elements about this time may also be seen to relate to Henry's notions about lines and colors eliciting particular emotional effects. Henry argued that lines moving upward and to the right, as well as warm colors, produce an uplifting effect; horizontal lines, and a balance of warm and cool colors, communicate calm; and lines moving downward, as well as cool colors, create negative emotions.[10]

Signac's changing aesthetic is powerfully evidenced in *Port of Saint-Cast, Opus 209*, which fully exploits the violet-blue–yellow complementary pairing to organize the composition. Also apparent is Signac's increasing fascination with Edo period Japanese woodblock prints, so influential among artists in France at the time. The painting's broad bands of bright color, geometric simplicity, empty foreground, and precise edges that demarcate one pictorial element from another derive from study of the East Asian prints.

Françoise Cachin has noted that Signac, Henri-Edmond Cross (1856–1910), and Maximilien Luce (1858–1941) began to find Japanese woodblock prints an increasingly compelling influence on their aesthetic about 1889, several years after Seurat was first drawn to them. She attributes to Japanese prints not only formal influences on these artists—increasing abstraction, simplified geometric forms, high horizon lines, and repeated motifs throughout the composition—but an entirely new approach to nature. Instead of looking for the anecdotal or momentary in nature, as did the Impressionists, these artists now began to depict "the grandeur of nature, of light, of the sky, of the

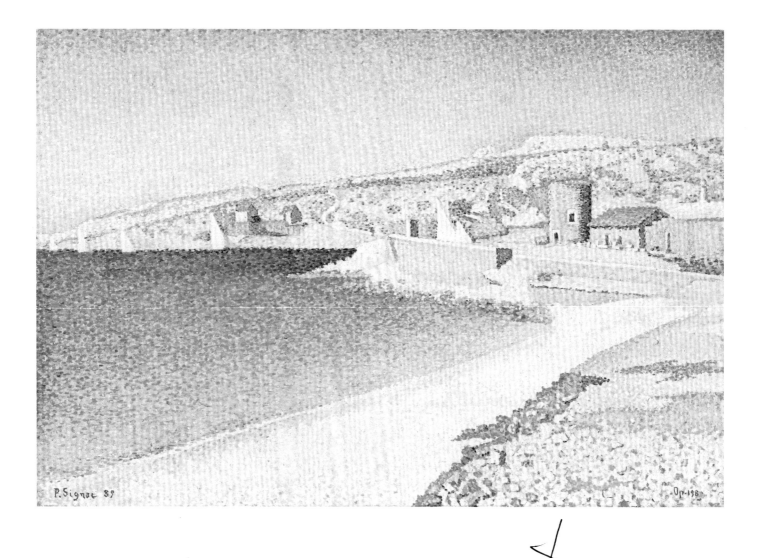

Fig. 6.
Paul Signac, *The Jetty at Cassis*,
1889, oil on canvas, 18¼ x 25⅝
inches, The Metropolitan
Museum of Art, New York,
Bequest of Joan Whitney
Payson, 1975 (1976.201.19)

seasons," with landscape now given "the respect of an icon, a nature, as it were, sacred [and] simplified. . . ."[11] Signac's paintings from about 1890 are strikingly different as well from his earlier works in the highly controlled application of paint in small dots and an unabashed focus on light. In *The Jetty at Cassis*, for instance, the intense burning light in the sky is reflected off the vast body of shimmering water and seems to penetrate what one imagines to be white-hot sand. Signac wrote of the light in Cassis: "there is nothing in that region but white. The light, reflected everywhere, consumes all the local colors and makes the shadows appear grey."[12]

A similar aesthetic is evident in Cross's *Coast near Antibes* (fig. 7), of 1891–92, made about the time the artist moved from Paris to France's southern coast, first to the town of Cabasson and then to Saint-Clair. Cross turned to Neo-Impressionism only in 1891, the year Seurat died, but he was to become one of the movement's key figures. The striking parallels between this work (circa 1891) and Signac's *The Jetty at Cassis* (1889) and *Port of Saint-Cast, Opus 209* (1890) are perhaps less surprising when one considers the artists' especially close relationship at this time. The two artists had been friends since 1884 and remained so until Cross's death in 1910, but about this time they seemed especially close, with Signac moving to Saint-Tropez in 1892, just miles from Cross's home. In this painting we again see the blanching effect of intense light on sea and coast, parallel spatial zones, a simplified range of colors, uncannily uniform dots, emphasis on the flatness of the surface, and precisely demarcated compositional elements.

Already in these several paintings one can sense the allure of water for this group of artists, especially Signac, who was an avid sailor throughout his life. Cachin, the artist's granddaughter, has noted that Signac "came to realize that the best part of his sensibility and of the pointillist technique were activated for him by scenes of sunshine and sea, by everything that sparkled . . . in the bright light."[13] Given the fact that virtually every Neo-Impressionist artist created paintings depicting water or its shoreline, this sentiment seems to have been shared almost universally.

Beyond France: Van Rysselberghe and Dutch Artists

Neo-Impressionism was not a cohesively defined movement; rather, it consisted of individual artists who were influenced in some way by the theories and/or technique that Seurat had pioneered. This influence first was felt in France, but by 1889 Neo-Impressionism was the primary avant-garde movement in Belgium, and by 1892 it had spread to Holland. Publications in 1898 and 1899 by Signac led to a revival of interest in divisionism that spread to Italy and elsewhere.[14]

The exhibition includes four paintings by the Belgian painter Théo van Rysselberghe (1862–1926) that date to 1892 and 1893, a portrait—the genre for which he is best known—and three seascapes. *Anna Boch* (fig. 8) is the earliest portrait included in this exhibition and is a powerful reminder that Neo-Impressionists did not only paint scenes

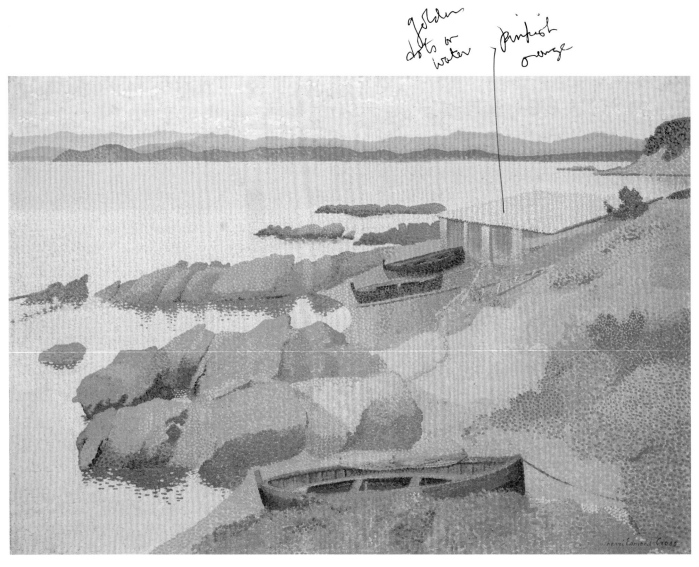

golden dots on water *pinkish orange*

Fig. 7.
Henri-Edmond Cross, *Coast near Antibes*, 1891–92, oil on canvas, 25⅝ x 36¼ inches, National Gallery of Art, Washington, John Hay Whitney Collection, 1982.76.2

of nature. Some of Signac's earliest Neo-Impressionist paintings, such as *The Dining Room, Opus 152* (1886–87; Kröller-Müller Museum, Otterlo, The Netherlands), depict members of his family; Cross's very first Neo-Impressionist painting was a large portrait of his wife; Luce painted countless portraits throughout his career; and Georges Lemmen (1865–1916), another Belgian artist, developed a unique approach to portraiture, creating beautiful and psychologically haunting works.

As the scholar Jane Block has pointed out, Van Rysselberghe's portraits "tend to focus more on palpable physicality than on psychological portrayal."[15] Here he shows Anna Boch (1848–1936)—an artist who studied with Van Rysselberghe, exhibited at Les XX (The Twenty, the foremost society showing avant-garde art in Belgium) and with its successor, La Libre Esthétique, and who briefly worked in the Neo-Impressionist style— holding a brush and palette. In the background is a Japanese print of the sort Boch collected (along with contemporary art). Also visible is part of a violin, a reference to Boch's skills as a violinist, organist, and pianist.[16] Boch was born to a family of master porcelain makers; in 1882 she met Van Rysselberghe through her cousin, Octave Maus, a founder of the weekly journal *L'Art moderne* and secretary of Les XX. The painting points to earlier traditions of portraiture, with the inclusion of objects that identify aspects of the sitter's personality and the attempt to create a lifelike resemblance of the sitter's features, even while adopting a radical style and means of applying paint.

Van Rysselberghe had seen Seurat's *A Sunday on La Grande Jatte–1884* (see fig. 49) and other divisionist paintings at the 1886 Impressionist exhibition in Paris, where he had gone seeking avant-garde art to exhibit at Les XX exhibition in Brussels; shortly thereafter he began experimenting with the technique. It was only about 1888, however, that he fully adopted a Neo-Impressionist approach, soon becoming the leading Belgian exponent of the style. Van Rysselberghe was very friendly with Signac, and Van Rysselberge most likely painted both *La Régate (The Regatta)* (see fig. 29) and *The Port of Sète (Le Port de Cette)* (see fig. 30) while he was visiting Signac on a journey along the Mediterranean coast in 1892.[17]

As we have seen, about 1890 Signac and Cross, increasingly influenced by Japanese prints, were turning their attention more and more toward surface patterning, divorcing line and color from their descriptive function. In *La Régate*, Van Rysselberghe demonstrates similar interests, using a dazzling array of meticulously applied dots to create an allover surface pattern that at times reads as pure geometry, as in the two-tiered sky and the rhythmic repetition of the sails. The predominant use of the violet and yellow pairing structuring the whole creates a sense of orderliness as well as of artifice. In brushwork and use of complementary color pairings, the painting represents one of Van Rysselberghe's purest applications of Neo-Impressionist principles. At the same time, the artist managed to create a sense of physical tangibility—positioning the viewer so as to dangle precipitously from the cliffs over a palpable body of rushing ocean water. This duality of artifice and physical reality is evident as well in another seascape from the same year, *The Port of Sète*, in which Van Rysselberghe depicts sailors (albeit schematized)

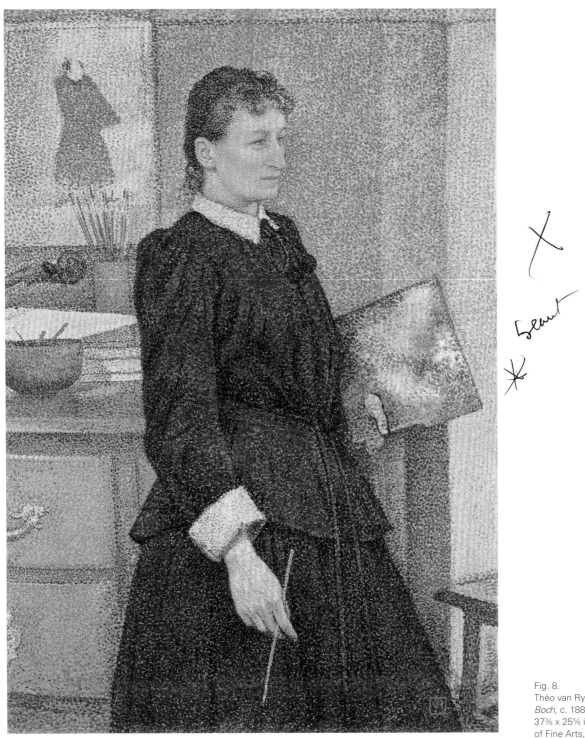

Fig. 8.
Théo van Rysselberghe, *Anna Boch*, c. 1889, oil on canvas, 37⅜ x 25⅝ inches, Museum of Fine Arts, Springfield, Massachusetts, James Philip Gray Collection, 70.04

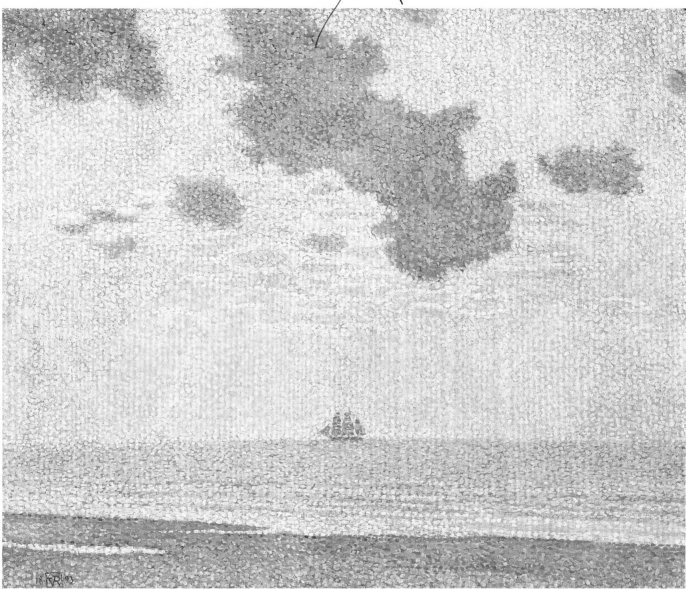

Fig. 9.
Théo van Rysselberghe,
Big Clouds (Gros nuages),
1893, oil on canvas, 19½ x 23½
inches, Indianapolis Museum of
Art, The Holliday Collection,
79.287

laboring on their boat in a busy commercial port, while masts, yardarms, sails, hulls, lighthouse, and a tower are rendered with a precision and linear delicacy that approach the fineness of architectural renderings.

Van Rysselberghe's *Big Clouds* (fig. 9) of 1893—a truly spectacular vision and a near–textbook essay in Neo-Impressionist technique and theory—offers a fascinating comparison to *La Régate* from the year before. Both works demonstrate a highly ordered compositional structure and an emphasis on surface patterning in the construction of a scene of the open seas. *La Régate*, however, is a painting that acknowledges the physical presence of a vast body of water, while *Big Clouds* explores the open sky and the way that all-pervasive light allows sky, water, and land to become optically one. As a result, the former conveys a sense of heaviness, of physicality or materiality, while the latter is sheer luminosity. Ellen Lee also observes a contrast within *Big Clouds* between the overall "flat planes," which dominate the composition, and "the sculptural essence of the cloud formation."[18] The sense of artifice created by the flat surface patterning is amplified by the artist's radical decision to limit his palette to two sets of complementary colors— yellow and violet, orange and blue—and by the very dark border painted along the edges of the canvas. While echoing nature's forms and colors, this painting is strikingly modernist in its formalist emphasis, establishing a tension between the conventions of painting and observed reality.

Van Rysselberghe's interest in two-dimensional design extended to the graphic and decorative arts. He was an important book illustrator, printmaker, and designer of posters and catalogues for exhibitions of Les XX and La Libre Esthétique. In 1895 he also "created furniture, stained glass, jewelry, and mural decorations for clients of Siegfried Bing's l'Art Nouveau gallery in Paris."[19] In 1902 he painted a mural for Hôtel Solvay in Brussels, a project of the renowned Art Nouveau architect Victor Horta. In his later years, he also sculpted.

Other non-French artists whose work is included in this exhibition are the Dutchmen Jan Toorop (1858–1928), Hendrik Pieter Bremmer (1871–1956), and Johannes Aarts (1871–1934). Toorop is generally credited with introducing Neo-Impressionism to Holland through his organization of an exhibition of French and Belgian Neo-Impressionist paintings there in 1892.[20] Toorop, who was born in Java, is well known for his Symbolist and Art Nouveau works, but he was profoundly moved early in his career by seven paintings by Seurat, exhibited in 1887 at the exhibition of Les XX, and works by Signac from the early 1890s.

Dunes and Sea at Zoutelande (fig. 10), one of Toorop's final Neo-Impressionist paintings, Bremmer's *Paysage avec maisons (Landscape with Houses)* (fig. 11), and Aarts's *Farm "De Bataaf"* all share aesthetic similarities to paintings by Signac and Cross from the late 1890s—geometric abstractions of form, a minimized range of increasingly bright artificial colors, and a strong sense of surface patterning and texture. The colors in these paintings are perhaps more striking than in any others in the present exhibition, offering an intense brilliancy and power that are impossible to ignore.

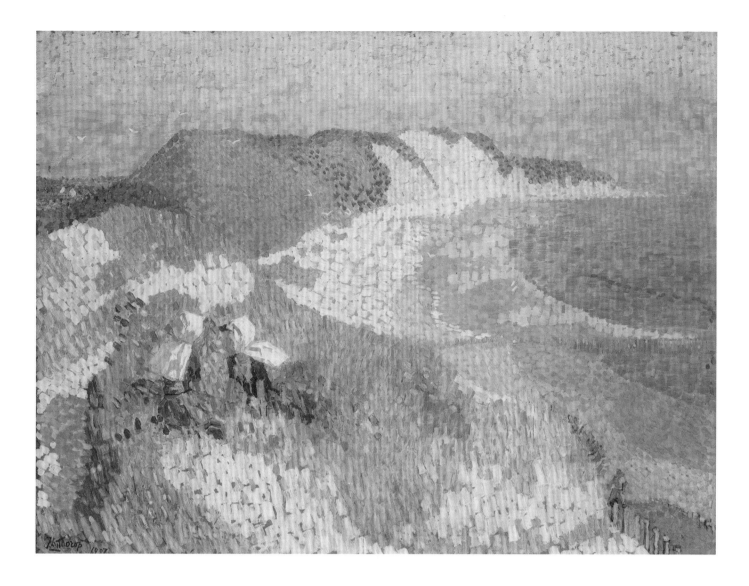

Fig. 10
Jan Toorop, *Dunes and Sea at Zoutelande*, 1907, oil and pencil on cardboard on panel, 18¾ x 24⅛ inches, Lent by The Gemeentemuseum Den Haag, The Hague, The Netherlands

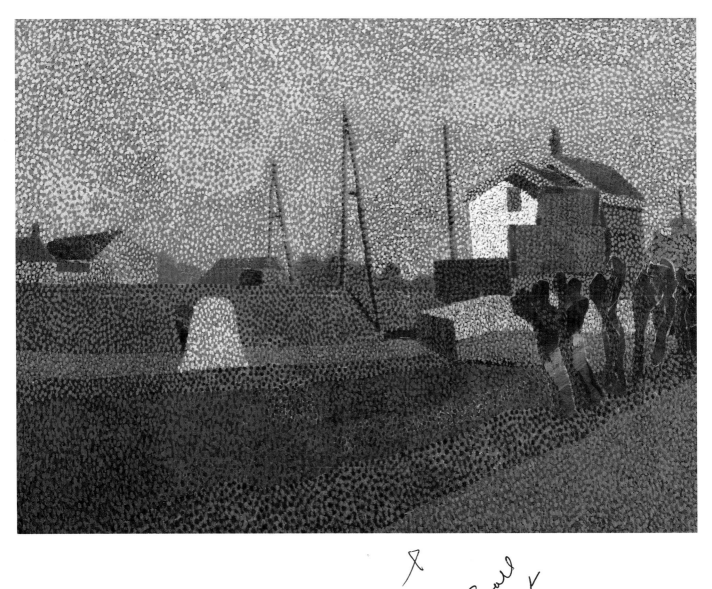

Fig. 11.
Hendrik Pieter Bremmer,
*Paysage avec maisons
(Landscape with Houses)*,
c. 1898, oil on canvas,
16½ x 22 inches,
Walter F. Brown Collection

Luce first became interested in Neo-Impressionism about 1887, largely through the influence of Camille Pissarro, who himself went through a Neo-Impressionist phase from 1885 to 1890. Though at times Luce closely adhered to Neo-Impressionist principles, he generally found the technique too restrictive for his temperament and hence applied the method less rigorously.[21] Thus by the mid-1890s, Luce was working in styles both more and less Neo-Impressionist.

Excellent examples of Luce's more purely Neo-Impressionist approach are *Morning, Interior* (fig. 12), of 1890, and *Camaret, la digue* (*The Breakwater at Camaret*) (see fig. 1), of 1895, both of which are executed in precise small dots and rely on complementary color pairings to render light, form, and space. In the beautifully rendered *Morning, Interior*—a portrait of Luce's friend and fellow Neo-Impressionist Gustave Perrot—the artist used colored light and shadow to create quasisculptural effects, as in the bedding and the almost palpable air. The precision of Luce's technique here is equaled by his attention to detail, as in the careful rendering of the accouterments Perrot used to prepare for the day as well as of the works of art that adorn the walls. Luce gently infused *Camaret, la digue* with soft, glowing colors that offer a distinct contrast to the brilliant intensity of *Morning, Interior*. In considering these two works, it becomes apparent that Luce was able to use the Neo-Impressionist approach to greatly varying ends, both successful.

Luce's *Port of London, Night* (1894, fig. 13) and *Portrait of a Boy* (1895, fig. 14), while clearly influenced by a Neo-Impressionist aesthetic, imply additional influences. In terms of the composition and tone, *Port of London, Night*, though executed in stippled brushwork, recalls the Nocturnes of the London-based American artist James McNeill Whistler from the 1870s (which looked to both nature and the conventions of Japanese woodblock prints) more than the highly stylized and increasingly abstracted seascapes of the 1890s being created by Luce's contemporaries. The charming *Portrait of a Boy*, in contrast to Van Rysselberghe's *Anna Boch*, for instance, seems more humanized and less contrived, recalling Impressionism, with its more fluid brushstrokes, casual pose of the subject, and the capturing of a seemingly spontaneous moment.

Other works in this exhibition by Luce reveal his leftist political views. Neo-Impressionism as a movement was intimately tied to leftist sociopolitical concerns of the 1880s and 1890s, particularly anarchocommunism.[22] John Hutton has written that the Neo-Impressionist movement was "a determined but fragile attempt to derive a 'harmonious' synthetic vision from contemporary science, anarchist theory, and late-nineteenth-century aesthetic debates."[23] As is often quoted, Signac wrote: "Justice in sociology, harmony in art: the same thing." He was not advocating overtly political subjects in art, but rather calling for a new art, which "battles with all [the artist's] . . . individuality against bourgeois and official conventions by making a personal contribution. The subject is nothing . . . no more important than the other elements."[24]

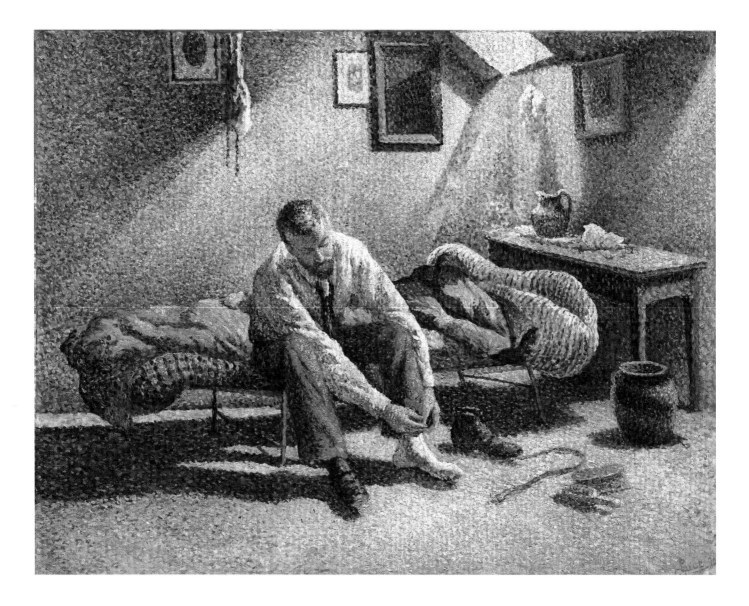

Fig. 12.
Maximilien Luce, *Morning, Interior*, 1890, oil on canvas, 25½ x 31⅞ inches, The Metropolitan Museum of Art, New York, Bequest of Miss Adelaide Milton de Groot (1876–1967), 1967 (67.187.80)

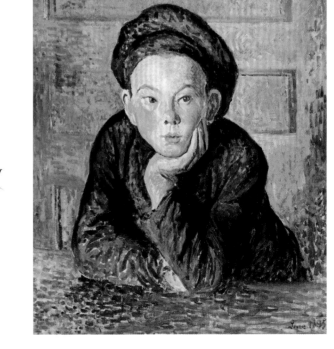

Fig. 13.
Maximilien Luce, *Port of London, Night (Port de Londres, La Nuit)*, 1894, oil on canvas, 28 x 35¼ inches, High Museum of Art, Atlanta, Georgia; Gift in memory of Caroline Massell Selig (1919–1984), 1985.22

Fig. 14.
Maximilien Luce, *Portrait of a Boy*, 1895, oil on canvas, 21 x 18¼ inches, Centennial gift of Mrs. Toivo Laminan (Margaret Chamberlin, Class of 1929), Davis Museum and Cultural Center, Wellesley College, Wellesley, MA, 1976.19

This new art would also convey certain values, such as permanence, harmony, and synthesis.[25] Politically active Neo-Impressionist artists—Luce, Pissarro, Cross, Signac, Van Rysselberghe—however, responded with their art in individual ways.

Luce, who was born into a working-class family in the Montparnasse section of Paris, was one of the most politically involved Neo-Impressionists, and he depicted proletarian subjects throughout his career, not only in his paintings and prints but also in numerous illustrations for socialist magazines. He knew many anarchist-communist leaders of the day, and in 1894 he was imprisoned for forty-two days under suspicion following the assassination of French president Sadi Carnot by an Italian anarchist (Luce was acquitted). Luce's powerful lithograph *The Arsonist* (fig. 15), published in Jean Grave's anarchist journal *Les Temps nouveaux* in 1896, may be read as an overt expression of the artist's radical ideals. Below the print Luce has copied in his own hand a poem written by the ardent Belgian social reformer Émile Verhaeren, which invokes the ominous personage of an arsonist bearing a "torch of gold, a fecund [?] sign of blood" rising "suddenly from a distance."[26]

Some of Luce's most interesting images are those of workers in Belgian coalmines and factories, laboring under oppressive conditions. The town of Charleroi and its environs were especially notorious for such offenses. In *Les Aciéries à Charleroi (Cheminée d'usine)* (*The Steelworks in Charleroi, Factory Chimney*) (fig. 16) of 1893, Luce shows laborers stooped over wheelbarrows, working beneath dwarfing, fume-emitting chimneys, made all the more noxious by Luce's choice of garish lighting raking over utter blackness. A more hopeful vision is presented in *Les Cheminées d'usines, Couillet près de Charleroi* (*The Factory Chimneys, Couillet near Charleroi*) (fig. 17), where two figures walk along a cleared path up and away from the valley of belching factories.

Cross's Idyllic Visions

At the same time that Luce was using a Neo-Impressionist technique, even as he looked back to a sort of gritty, if sometimes hopeful, realism, Cross, from about 1895 to 1903, painted scenes that were ever more idyllic, imaginative, and optimistic, some of which can be interpreted politically. These paintings—which bear formal similarities to contemporary cutting-edge movements like the Nabis, Symbolism, and Art Nouveau—may be distinguished from Cross's works of 1891 to 1895, the years of the artist's most orthodox adherence to Neo-Impressionism. The mid-1890s brought changes in Cross's choice of subject, light, color, and technique. As Cross's biographer Isabelle Compin has noted, Cross, now believing that the effects of light could not be rendered with accuracy in painting, chose instead to suggest light's overall intensity and to emphasize its ability to harmonize or unify differing compositional elements.[27] His colors became more daring, heightened, unusual, and sumptuous; and, though he continued to use color contrasts, he replaced his dotted strokes with narrow, longer brushstrokes "stretching in all directions" (which about 1902 were in turn replaced by square touches).[28]

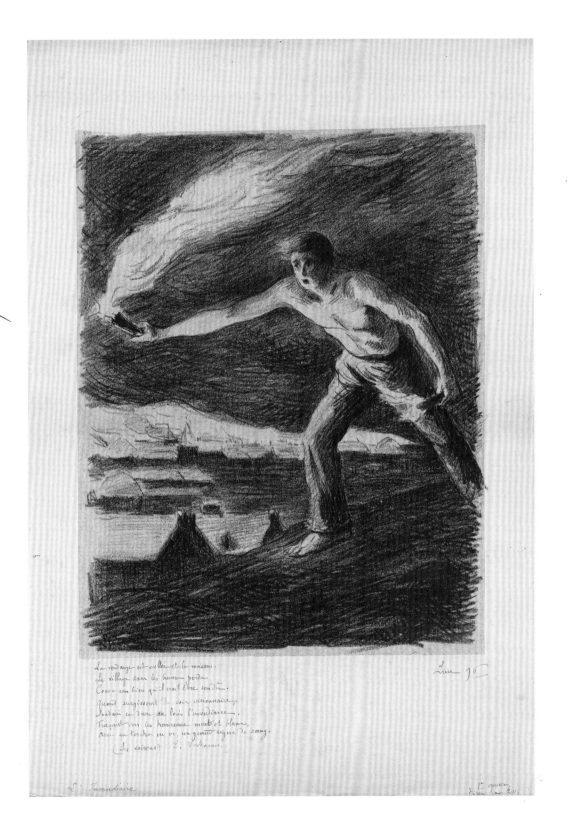

Fig. 15.
Maximilien Luce, *The Arsonist*,
1895–96, lithograph printed in
black on gray-blue wove paper,
mounted by artist, sheet:
15¼ x 11⅞ inches, Courtesy of
the Fogg Art Museum, Harvard
University Art Museums,
Deknatel Purchase Fund

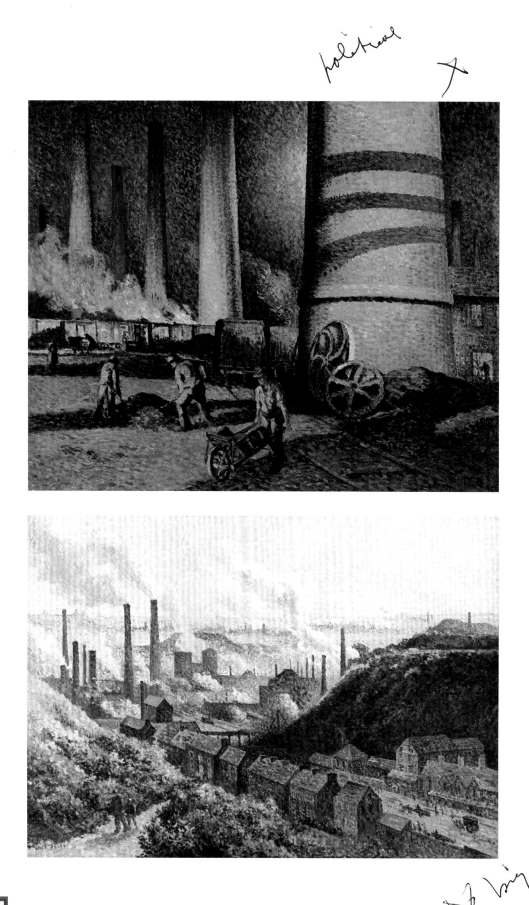

Fig. 16.
Maximilien Luce, *Les Aciéries à Charleroi (Cheminée d'usine) (The Steelworks in Charleroi, Factory Chimney)*, 1896, oil on canvas, 23 x 28 inches, Private collection

Fig. 17.
Maximilien Luce, *Les Cheminées d'usines, Couillet près de Charleroi (The Factory Chimneys, Couillet near Charleroi)*, 1898–99, oil on canvas, 28¾ x 39½ inches, Walter F. Brown Collection

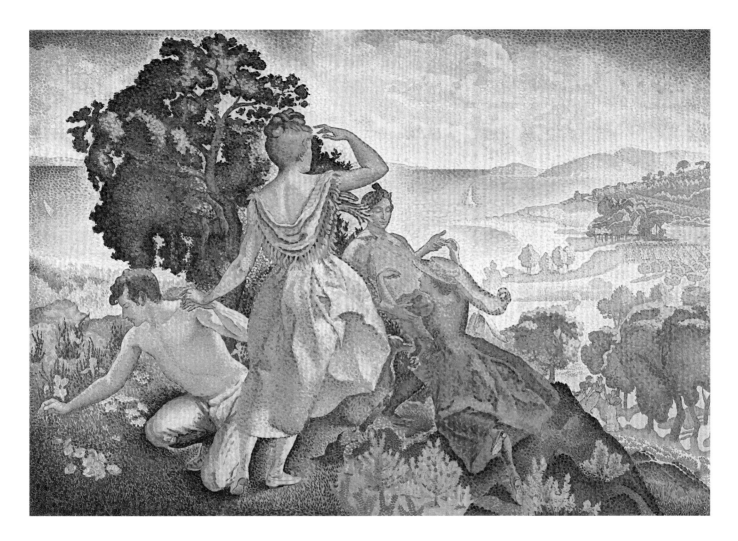

X stylized

Fig. 18.
Henri-Edmond Cross,
Excursion, 1895, oil on canvas,
45¾ x 64¾ inches, Chrysler
Museum of Art, Norfolk, VA;
Gift of Walter P. Chrysler, Jr.,
77.416

Cross's powerful painting *Excursion* (fig. 18), from 1895, reflects many of these changes, in terms of both choice of subject, which is more allegorical and idyllic, and technique, in terms of color and brushwork. Here Cross offers a vision of harmonious living, an imagined peaceful realm of existence where adult men and women live in accord with nature and with each other. One author has noted that the arcadian mood recalls the eighteenth-century *fêtes galantes* painted by Antoine Watteau, while its "decorative surface patterns—its sweeping curves and arabesques—bring to mind the contemporary work of the Nabis."[29] The figures in *Excursion*, perhaps unlike the urbane, holidaying dandies who populate the compositions of Watteau, are at one with nature, even of nature, brought to life, as it were, by its elemental forces. The painting's title points to vacationers or people simply at rest, yet the purposeful, energized figures of *Excursion* also suggest a fully charged state of idyllic human living, where a strong and healthy humankind draws sustenance from a bountiful and untainted natural world. Another painting from this period in Cross's career is the unabashedly joyful and celebratory *At the Fair* (see fig. 44) of 1896. The festiveness of the occasion is echoed formally in Cross's intoxicating color choices and the energetic patterns created by enthusiastic dancers, fluttering flags, and delicate, sweeping sails.

An interesting contrast to *Excursion* and *At the Fair*, works about leisure, is *The Grape Harvest (Var)* (fig. 19), of 1892, which blends Cross's Japanese-influenced aesthetic with an uplifting political message about a world in which people work. Here Cross offers a stunning bucolic view of grape pickers in a valley near the Mediterranean coast; workers are in harmony with the bountiful natural world in which they bend, lift, and carry, seemingly unburdened by their activities. In representing a mood of peaceful endeavoring, rather than the backbreaking labor that harvesting really is, the painting can be interpreted as a model of ideal living. This is not a vision of a golden age, where work gets itself done, or an arcadian reflection of things past; rather, it appears to be a merging of the present and a possible future where labor is not oppressive and nature is always munificent.

After 1903 Cross's social vision often seems to have blended with personal fantasy, with the artist frequently taking the female nude as his subject, especially in the guise of nymphs and bathers, who are sometimes shown as part of an idyllic realm, but at other times more superficially. The Belgian Symbolist poet and critic Emile Verhaeren wrote about Cross in 1905: "As you have written to me, your dream is for your art to be not only the 'glorification of nature' but the 'glorification [*sic*] of an inner vision.'"[30] One also senses Cross's pleasure in creating peaceful and uplifting works around this time, such as *The Little Maures Mountains* (fig. 20) and *L'Arbre penché, ou Le Rameur (The Leaning Tree, or The Rower)* (fig. 21). Unlike the dynamic *Excursion*, which presents a vision of idyllic yet energized societal living (with one group of people beckoning another), *The Little Maures Mountains*, a landscape in intense blues and yellows, depicts a similar sense of peace and perhaps even hopefulness, with its pristine mountain view. *L'Arbre penché, ou Le Rameur* offers a lyrical rendering of utter relaxation and peace for individuals who

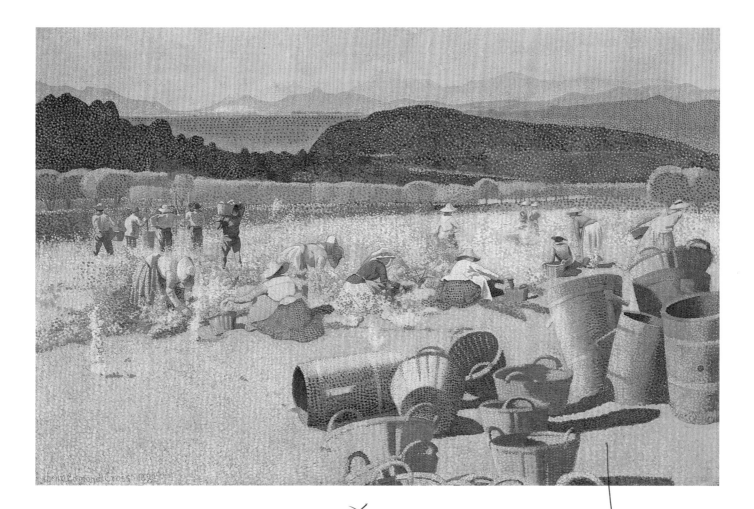

Fig. 19.
Henri-Edmond Cross, *The Grape Harvest (Var)*, 1892, oil on canvas, 37⅜ x 55¼ inches, The Museum of Modern Art, New York, Mrs. John Hay Whitney Bequest, 1998

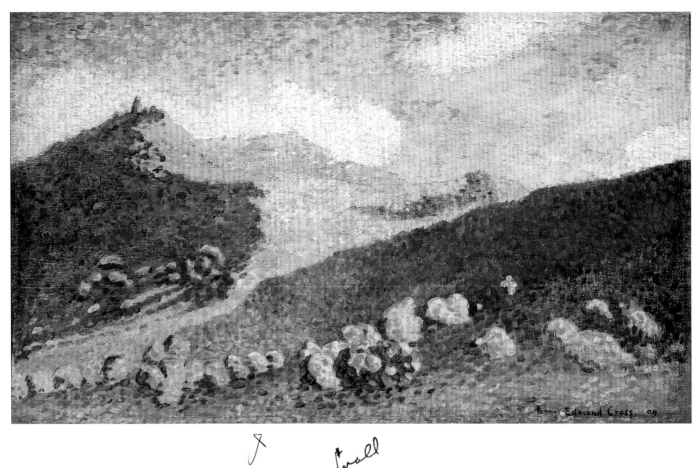

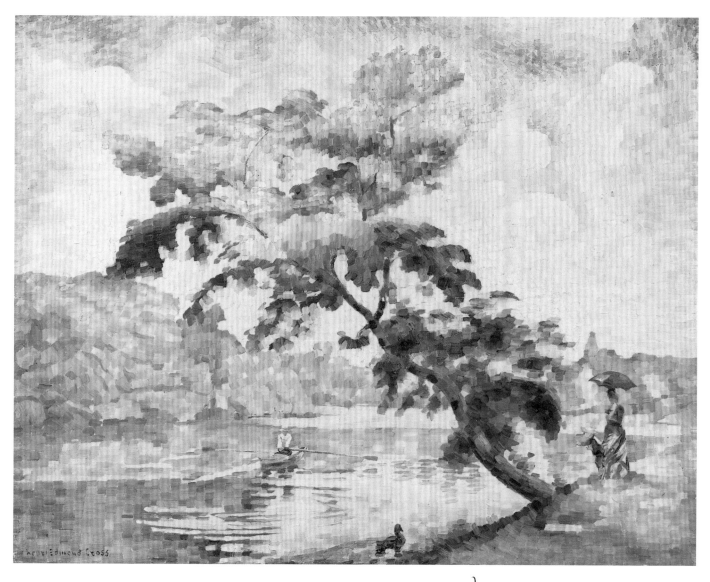

Fig. 21.
Henri-Edmond Cross, *L'Arbre penché, ou Le Rameur (The Leaning Tree, or The Rower)*, c. 1905, oil on canvas, 25½ x 31⅞ inches, Private collection

have stepped outside society. The large blocks of almost transparent color in shades of violet, yellow, pink, and green impart a soft, dreamlike quality to this poetic scene of peaceful escape.

Newcomers and Old-timers about 1900

Best known for his association with Cubism, Jean Metzinger (1883–1956) embarked on a distinct and impressive Neo-Impressionist phase soon after his arrival in Paris in 1903. By 1905 the height of Neo-Impressionism had already passed, but interest in it had been renewed thanks to various Neo-Impressionist exhibitions as well as publications by Signac, most notably his 1899 book *D'Eugène Delacroix au néo-impressionnisme*, which introduced Neo-Impressionist principles to a new generation. Metzinger was not the only convert around this time: in 1904 Henri Matisse was an ardent student of Neo-Impressionism, working with Signac and Cross in Saint-Tropez in the summer of 1904; by 1905 he had moved into the Fauvist stage of his career.

Metzinger's *Paysage pointilliste (Pointillist Landscape)* (fig. 22) of circa 1907 presents a delightful, slightly fantastical seascape executed in large tessera-like brushstrokes placed meticulously side by side. Metzinger wrote: "I ask of divided brushwork not the objective rendering of light, but iridescences and certain aspects of color still foreign to painting."[31] Such iridescent color allows *Paysage pointilliste* to shimmer, emitting an aura of the fantastic or spectacular. The playful arrangement of miniature boats and trees seems almost childlike and certainly whimsical. An earnest Metzinger apparently studied the writings of Michel-Eugène Chevreul and Ogden Rood, whose theories about color heavily inform Neo-Impressionist ideas, and this rigorously executed painting—from fairly early in the artist's career yet well past the prime of Neo-Impressionism—attests to the seriousness of his intentions toward Neo-Impressionism, as well as to the enduring appeal of this older movement to the Parisian avant-garde.

An even earlier work by him, *Paysage avec bateaux à voiles (Landscape with Sailboats)* (fig. 23) seems to push the very limits of representationalism, with its coastal scene rendered microscopically, with every particulate exposed. Here the divisionist strokes, again like tesserae in a mosaic, emerge as forms nearly independent of that which they represent.

Later Manifestations

As we have seen, Neo-Impressionism went through ever-changing incarnations throughout the late 1880s, 1890s, and 1900s; these changes were evident not only in the oeuvres of individual artists but also in small groups of artists at given times (such as Signac, Cross, and Van Rysselberghe in the early 1890s). With the advent of Fauvism,

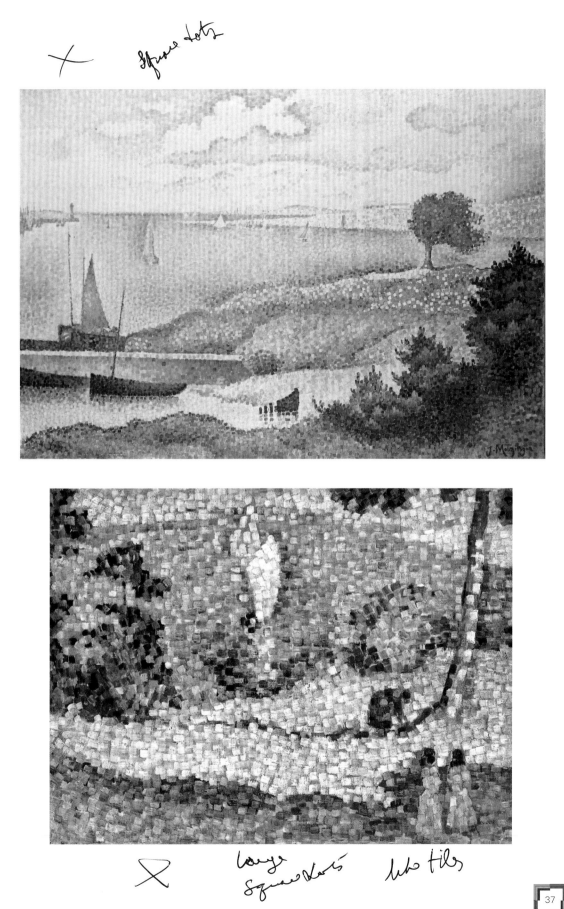

Fig. 22.
Jean Metzinger, *Paysage pointilliste (Pointillist Landscape)*, c. 1907, oil on canvas, 25¾ x 36½ inches, Walter F. Brown Collection

Fig. 23.
Jean Metzinger, *Paysage avec bateaux à voiles (Landscape with Sailboats)*, c. 1902, oil on canvas, 18½ x 25 inches, Norton Museum of Art. Purchased through the R. H. Norton Fund, J. Ira and Nicki Harris Foundation, Anne and Harold Smith and Nanette Ross, 99.86

however, and soon thereafter of Cubism, the most progressive artists working in Paris no longer felt compelled to explore the principles of Neo-Impressionism.

Signac, the longtime exponent of Neo-Impressionism, continued to reinvent his approach, giving the movement a level of endurance one might not have imagined possible. Like Cross in the late 1890s, Signac introduces ever more unnaturalistic and heightened colors into his paintings, as well as a linear surface patterning strongly akin to that of Art Nouveau. Both *Entrance to the Grand Canal, Venice* of 1905 (fig. 24) and *Port d'Antibes* of 1909 (fig. 25) display such tendencies. In the former, which highlights Santa Maria della Salute and gondolas, sweet pinks and hot yellows dominate what is, on closer examination, a complex of subtle color variations. An increasing emphasis on two-dimensionality is sensed, especially in the undulating clouds and the intricate pattern of brushstrokes creating the gondolas, pilings, and piers; indeed, one has to look closely at the latter to notice what turns out to be a sizable number of people moving on and about the boats.

A few years later, in the masterfully luminous *Port d'Antibes*, Signac reveals not only his abiding commitment to Neo-Impressionist concerns but also a fascination with Art Nouveau linearity and Fauve color. The sinuous trunk and flowing branches that form the dramatic tree in the right foreground provide a breathtaking frame for the rich scene that unfolds in the middle and far distances. The tree's languorous extension across the picture plane allows it to stand as a remarkable formal entity in and of itself, an exquisite example of surface design and patterning. Also of note in this work is the mingling of the familiar blanched Neo-Impressionist palette—soft pinks, blues, greens, and yellows—with the ultrahot red and oranges so typical of Fauve landscapes around this time.

A pacifist, Signac was depressed about World War I and produced only sixteen canvases between 1914 and 1917.[32] According to Maria Ferretti-Bocquillon, *Antibes, le nuage rose (Antibes, the Pink Cloud)* (see fig. 36), of 1916, "stands out among the otherwise subdued paintings of the war years, combining dreamlike aspects tinged with humor . . . with the unsettling vision of warships . . . parading on the horizon."[33] Ferretti-Bocquillon also notes that this painting looks back to a work by Cross (who had died in 1910) called *Le Nuage rose (Pink Cloud)*.[34] Hence, we see here a painting that, while executed in the divided strokes and color pairings of Neo-Impressionism, is distinctly different from works the artist created in the decades before. It is a work drawn equally, it seems, from nature, imagination, and memory.

It should be noted here that watercolor, a medium Signac began to explore seriously in 1892, played an important role for the artist throughout the remainder of his life. Indeed, between 1929 and 1931, only several years before his death, Signac devoted himself to traveling along France's coast, producing major watercolors of various harbors, a series he had hoped to have published during his lifetime. Many authors have noted that for Signac watercolor allowed a freedom of expression and aesthetic variety not so easily achieved using the rigorous technique associated with Neo-Impressionist oil painting.

Such freedom is evident in this exhibition in two watercolors by Signac, *La Rochelle* (fig. 26), perhaps from circa 1920,[35] and *View of Notre Dame, Paris*, of circa

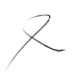

Fig. 24.
Paul Signac, *Entrance to the Grand Canal, Venice*, 1905, oil on canvas, 29 x 36¼ inches, Toledo Museum of Art; Purchased with funds from the Libbey Endowment, Gift of Edward Drummond Libbey, 1952.78

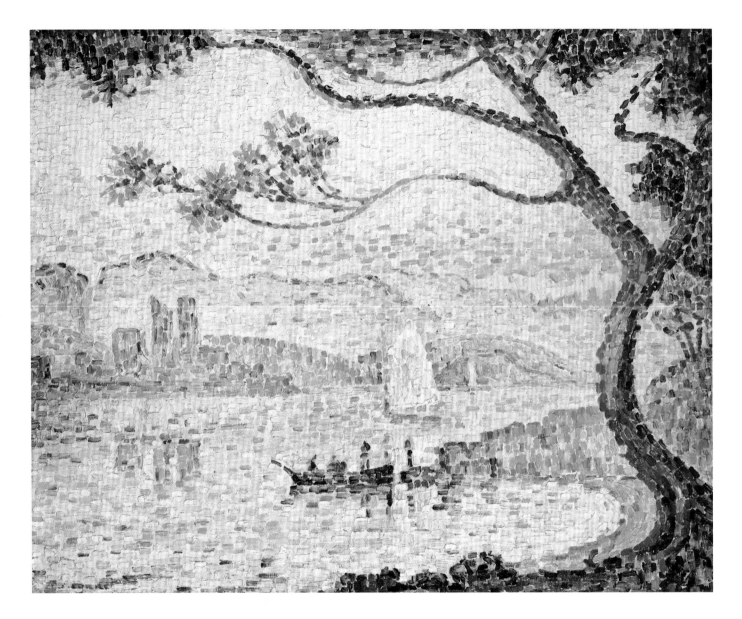

Fig. 25.
Paul Signac, *Port d'Antibes*,
1909, oil on canvas, 21¼ x 25½
inches, The Whitehead
Collection, courtesy Achim
Moeller Fine Art, New York

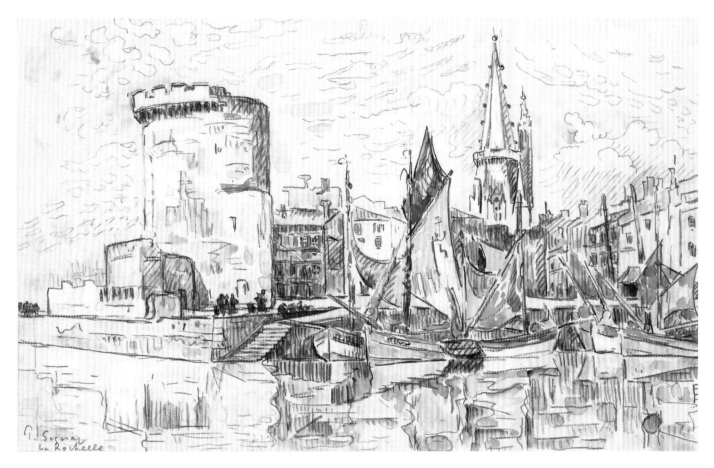

Fig. 26.
Paul Signac, *La Rochelle*,
undated, watercolor and conté
crayon on off-white laid paper,
10¾ x 16⅞ inches, Courtesy of
the Fogg Art Museum, Harvard
University Art Museums, Gift of
James Naumburg Rosenberg,
in memory of Aaron and Nettie
Goldsmith Naumburg, on the
Twenty-fifth Anniversary of the
Opening of the Naumburg Wing
of the Fogg Art Museum,
November 8, 1957

1924, which demonstrate very different aesthetics. Though both speak to the artist's continuing fascination with water, the former, somewhat like Signac's oils, depicts a port and demonstrates an abiding interest in the use of intense color as well as the point, while the latter is urban and more lyrical in tone and application.

While Signac continued to reinvigorate Neo-Impressionism in the early twentieth century, other artists experimented with various aspects of the technique. Henri Martin (1860–1943), for example, had adopted the brushstroke, if not the color theory or subjects, of Neo-Impressionism about 1889, applying it in the 1890s to Symbolist subjects as well as to more traditional historical and literary scenes and then, after 1900, primarily to landscapes. Signac was appalled by Martin's approach, writing, "Is it really worth applying divisionism, to do it uselessly, with impure colors and no advantage whatever?"[36] *Le Pont, l'église et l'école de La Bastide-du-Vert (The Bridge, Church, and School of La Bastide-du-Vert)* (fig. 27), a work from 1920, is executed in controlled pointillist strokes and demonstrates careful attention to the play of light, though not through the use of complementary unmixed pigments; indeed, earth tones reign in this charming rustic view of the town in which the artist had a home.

Still other artists working in the 1910s and 1920s who are not strongly identified with the movement in its heyday found varying degrees of inspiration from Neo-Impressionism. Ludovic de Vallée (1864–1939?), for example, working in the mid-1920s, painted *La Plage au pied de la falaise (The Beach at the Foot of the Cliff)* (fig. 28) using divided strokes and strangely echoing the rigidity and poses of certain figures by Seurat; this, despite the fact that he had worked the decade before in a style more overtly Art Nouveau and design-oriented. While not Neo-Impressionist per se, this work nonetheless points to the continuing allure of the formal aspects of the movement, even decades after its peak.

In Sum

The paintings that constitute *Neo-Impressionism: Artists on the Edge*, as well as this essay, reveal the richness, diversity, and longevity of the multifaceted approach to light and color known as Neo-Impressionism. Both underscore that Neo-Impressionism was not a monolithic movement, not in terms of style, technique, subject, or artistic theme or intent; and while Neo-Impressionism peaked in the decade following Seurat's introduction of his new approach, it would capture the imagination of artists of both that first generation and several generations to follow. In its diversity this exhibition also suggests that the renewal of interest in Neo-Impressionism that has been evidenced in recent years is well placed[37]—Neo-Impressionism is a complex movement that allows for, and warrants, continued scrutiny.

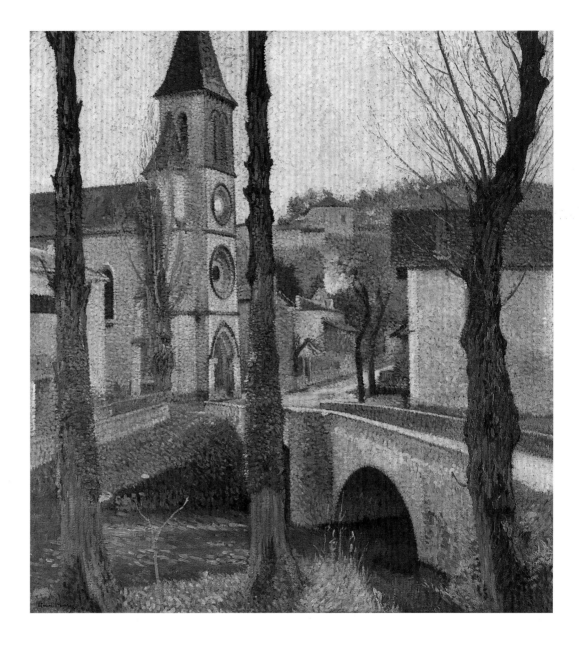

Fig. 27.
Henri Martin, *Le Pont, l'église et l'école de La Bastide-du-Vert (The Bridge, Church and School of La Bastide-du-Vert)*, 1920, 45¾ x 43¾ inches, Walter F. Brown Collection

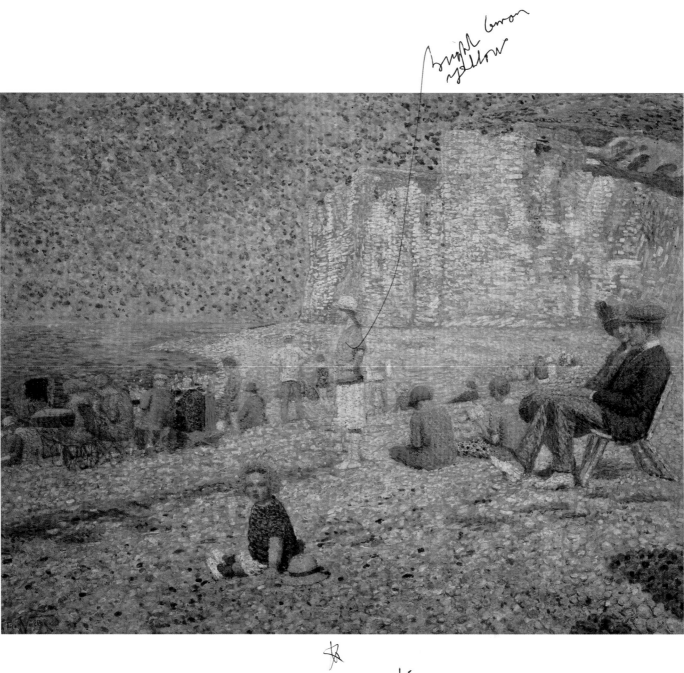

Fig. 28.
Ludovic de Vallée, *La Plage au pied de la falaise (The Beach at the Foot of the Cliff)*, 1924–26, 37⅝ x 46⅞ inches, Walter F. Brown Collection

Notes

1. As Ellen Wardwell Lee has noted, however, Seurat did allow the mixing of the various hues on his palette, which numbered up to eleven, with a hue's neighbor on the chromatic wheel or with any amount of white. Ellen Wardwell Lee, *The Aura of Neo-Impressionism: The W. J. Holliday Collection*, exh. cat. (Indianapolis: Indianapolis Museum of Art, 1983), p. 18.

2. The straddling evident in the work by Signac is interesting, since by about mid-1886 he had begun painting overtly divisionist works; apparently the artist was selective at this time about which works he chose to execute in a more purely Neo-Impressionist style and technique.

3. Eva Mengdon, *In Perfect Harmony: Picture + Frame, 1850–1920*, exh. cat. (Amsterdam: Van Gogh Museum, 1995), p. 154.

4. Robert Herbert, with Françoise Cachin, Anne Distel, Susan Alyson Stein, and Gary Tinterow, *Georges Seurat, 1859–1891*, exh. cat. (New York: The Metropolitan Museum of Art, 1991), p. 318.

5. Quoted in Herbert, 1991, p. 327.

6. Mengdon, 1995, pp. 158 and 161.

7. For possible ancient and contemporary influences on Seurat that relate to notions of the ideal, see Paul Smith, *Seurat and the Avant-Garde* (New Haven and London: Yale University Press, 1997).

8. This is a practice Signac adopted between 1887 and 1893.

9. General comparisons between music and painting were by no means new, and indeed had recently been highlighted by James McNeill Whistler, who beginning in the 1870s gave his paintings titles such as *Nocturne, Harmony,* and *Symphony.*

10. Henry first published these ideas in 1885 in the article "Introduction à une esthétique scientifique" in *La Revue contemporaine* 2 (May–August 1885): 441–69.

11. Author's translation. Françoise Cachin, "Les Néo-Impressionnistes et le Japonisme, 1885–1893," in *Japonisme in Art: An International Symposium*, ed. The Society for the Study of Japonisme (Tokyo: Committee for the Year 2001, 1980), p. 229.

12. Author's translation. John Rewald, ed., "Extraits du journal inédit de Paul Signac," *Gazette des Beaux-Arts* 36 (July–September 1949): 106, entry for September 29, 1894.

13. Françoise Cachin, *Paul Signac*, trans. Michael Bullock (Greenwich, Conn.: New York Graphic Society, 1971), p. 38.

14. Paul Signac, *D'Eugène Delacroix au néo-impressionnisme* (Paris: Éditions de la Revue blanche, 1899). Excerpts published in *La Revue blanche*, May–July 1898, and in *Pan*, July 1898, pp. 55–62.

15. Jane Block, "Portrait of Anna Boch," in *Impressionism to Symbolism: The Belgian Avant-Garde, 1880–1900*, ed. MaryAnne Stevens with Robert Hoozee, exh. cat. (London: Royal Academy of Arts, 1994), p. 242.

16. Block, 1994, p. 242 n. 1.

17. It is also known that Signac participated in a regatta in Marseilles during the time of this visit.

18. Lee, 1983, p. 59.

19. Russell T. Clement and Annick Houzé, *Neo-Impressionist Painters: A Sourcebook on Georges Seurat, Camille Pissarro, Paul Signac, Théo Van Rysselberghe, Henri Edmond Cross, Charles Angrand, Maximilien Luce, and Albert Dubois-Pillet* (Westport, Conn.: Greenwood Publishing Company, 1999), p. 267.

20. Indeed, it was in 1892 that Bremmer, a new graduate of the Hague Academy, adopted a version of this style. In addition, Bremmer was an adviser to Helene Kröller-Müller, whose art collection forms the core of the Kröller-Müller Museum in Otterlo, so impressive for its Neo-Impressionist holdings.

21. John Rewald, *Post-Impressionism: From Van Gogh to Gauguin*, 3d ed. (New York: The Museum of Modern Art, 1978), pp. 119–20.

22. For an expansive discussion of the relationship between Neo-Impressionism and politics, in all its multifaceted complexity, see John G. Hutton, *Neo-Impressionism and the Search for Solid Ground: Art, Science, and Anarchism in Fin-de-Siècle France* (Baton Rouge: Louisiana State University Press, 1994).

23. Hutton, 1994, p. 4.

24. Cachin, 1971, p. 73.

25. Hutton, 1994, p. 34.

26. Translated from Harvard University Art Museum notes, "Soudain se dresse du loin l'incendiaire/. . ./Avec sa torche en or, un fecond [?] signe de sang."

27. Isabelle Compin, "Henri Edmond Cross, 1856–1910," in *The Neo-Impressionists*, ed. Jean Sutter (Greenwich, Conn.: New York Graphic Society, 1970), p. 72.

28. Compin, 1970, p. 74.

29. Jefferson C. Harrison, *The Chrysler Museum: Handbook of the European and American Collections* (Norfolk, Va.: The Chrysler Museum, 1991), p. 162.

30. Compin, 1970, p. 74.

31. Quoted in Joann Moser, *Jean Metzinger in Retrospect* (Iowa City: The University of Iowa Museum of Art, 1985), p. 34.

32. Marina Ferretti-Bocquillon et al., *Signac, 1863–1935*, exh. cat. (New York: The Metropolitan Museum of Art, 2001), p. 252.

33. Ferretti-Bocquillon et al., 2001, p. 252.

34. Ferretti-Bocquillon et al., 2001, p. 174. The painting by Cross dates to circa 1896.

35. Signac visited La Rochelle intermittently between 1911 and 1930; Peter A. Wick suggests the date of circa 1920 in "The Port of La Rochelle by Paul Signac," *The Annual Report of the Fogg Art Museum, 1957–1958*, Harvard University (1959): 53.

36. From Signac's diary, quoted in Lee, 1983, p. 140.

37. For instance, *Signac, 1863–1935*, Galeries nationales du Grand Palais, Paris, February 27–May 28, 2001; Van Gogh Museum, Amsterdam, June 15–September 9, 2001; and The Metropolitan Museum of Art, New York, October 9–December 30, 2001; *Cross et le néo-impressionnisme*, Musée de la Chartreuse de Douai, October 3, 1998–January 4, 1999; *Pointillisme: Sur les traces de Seurat*, Wallraf-Richartz-Museum, Cologne, September 6–November 30, 1997, Fondation de l'Hermitage, Lausanne, January 23–June 1, 1998.

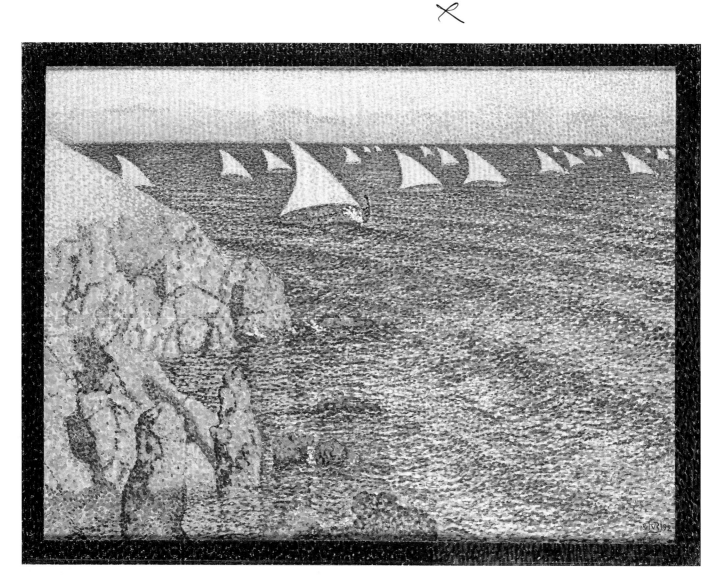

Fig. 29.
Théo van Rysselberghe, *La Régate (The Regatta)*, 1892, oil on canvas with painted wood liner, 23⅞ x 31¾ inches, Scott M. Black Collection

Neo-Impressionism, Puvis de Chavannes, and the Decorative Aesthetic

Michael Marlais

Planned, tightly controlled, and geometrically regulated, *La Régate (The Regatta)* (fig. 29) by Théo van Rysselberghe exemplifies the very essence of Neo-Impressionist style. Impressionist naturalism is in the painting's ancestry, with its plein-air representation of boats, water, sunlight, and leisure. But the soul of this painting is an abstract structure imposed on nature. Like all representational art, it is a dialogue between the abstract and the real, but here the abstract speaks louder.

Whether glanced at from across a gallery or studied carefully, *La Régate* is about geometric shapes interacting with each other in abrupt encounters over the flat surface of the canvas. The basic formal elements of the composition are the interrelated flat planes of water, land, and sky, the meeting of which in the upper left corner of the painting is as important as any depicted element. The sails wedging across the surface abet the interlocking, interpenetrating shapes of blue water and yellow rocks. If the blue seems to push the yellow rocks toward the left, the sails answer back forcefully. The smaller arcs of the sails are extended in the large arcs of the waves like the elaboration of a musical theme. At the upper left the rock plays at being a sail, harmonizing with the yellow shapes of the sails and anchoring the pointed wedge of their overall position on the canvas.

Details are no less telling of the artificial abstraction the artist has imposed on nature. One third of the way from the right-hand edge of the canvas is a group of three sailboats—largest in front, next in size up and just to the left, and smallest again a bit farther up and to the left. Their relative sizes and their placement relative to each other suggest the size diminution of objects receding in real space. But the illusion is emphatically broken by the way the curve of the back of the first sail and the front of a sail of equal size just to the left create a well-defined blue shape that reads as if it is a blue sail inverted

in the direction opposite to all of the yellow sails. This kind of optical effect happens again with the boat farthest to the left, where rock and sail conspire to articulate an expanse of water as another inverted sail shape. Indeed, wherever the water meets the left side of the sails, it asserts itself as a flat blue shape pushing against the yellow shapes. To a naturalist painter, such evidence of contrived composition was to be avoided, but Van Rysselberghe celebrates abstraction. Notice how the tips of the sails play with the horizon, reminding the viewer that the horizon is, after all, a line drawn across a two-dimensional surface. Are those boats or pieces of paper hanging from a line?

One finds similar abstract arrangements throughout Van Rysselberghe's work of this period. *The Port of Sète (Le Port de Cette)* (fig. 30), for instance, is marked by a balanced harmony of curves (the sails, the hulls of the boats) and straight lines (the lighthouse, the masts of the boats). The viewer's attention is forcefully drawn to the left edge of the painting. There the prow sprit of the boat just touches the edge of the painted frame of the canvas, dividing the vertical side of the canvas into a golden section.[1] The arcs of the sails of the same boat point to a spot on the top horizontal dimension of the canvas that is of similar proportion.

Van Rysselberghe was not alone in making two-dimensional patterns a major focus of his paintings. It was a central tenet of much Neo-Impressionist painting, as important in its own way as the more famous and more commented-on "scientific" application of paint. While the outer border of Albert Dubois-Pillet's *Sous la lampe (Under the Lamp)* of circa 1888 (fig. 31) serves to enrich the color harmonies of the still life, it also helps make the entire surface read like a flat target rather than a framed view. This effect is enhanced by the nature of the depicted still life—a series of angles, planes, cones, spheres, and circles, as much as a lamp, inkwell, or anything from the "real" world. In Henri-Edmond Cross's *Antibes, après-midi (Antibes in the Afternoon)* (fig. 32), a bend in the rightmost foreground tree trunks is positioned at precisely the spot where the line of the quays of Antibes meets the water, as if the trees gave birth to the linear movement across the canvas. His *The Grape Harvest (Var)* (see fig. 19) presents an accumulation of rounded forms—baskets, skirts, hats, and hills—that are pleasing simply as shapes, no matter what they describe. Paul Signac's *Port of Saint-Cast, Opus 209* (see cover) offers a series of interlocking flat planes of color that read as simple, stable shapes as much as they remind one of sand, water, rock, and sky. An earlier, and more Impressionist and naturalistic—if still carefully structured—painting by Signac, *View of the Seine at Herblay, Opus 203* (see fig. 4), offers a good counterpoint to the view of Saint-Cast. In the Herblay scene, the edges of water and land and sky are sketchy, less linear than in the Saint-Cast view, where edges become defining moments, isolating and defining abstract shapes.

Georges Seurat was a master of formal abstract order and certainly stimulated the rest of the Neo-Impressionists to follow his lead. Paintings such as his *A Sunday on La Grande Jatte–1884* (see fig. 49) and *Bathers at Asnières* (The National Gallery, London) were hailed in their day for their break from Impressionist naturalism toward a new "hieratic" style that was compared with Egyptian art and the ancient relief sculptures of

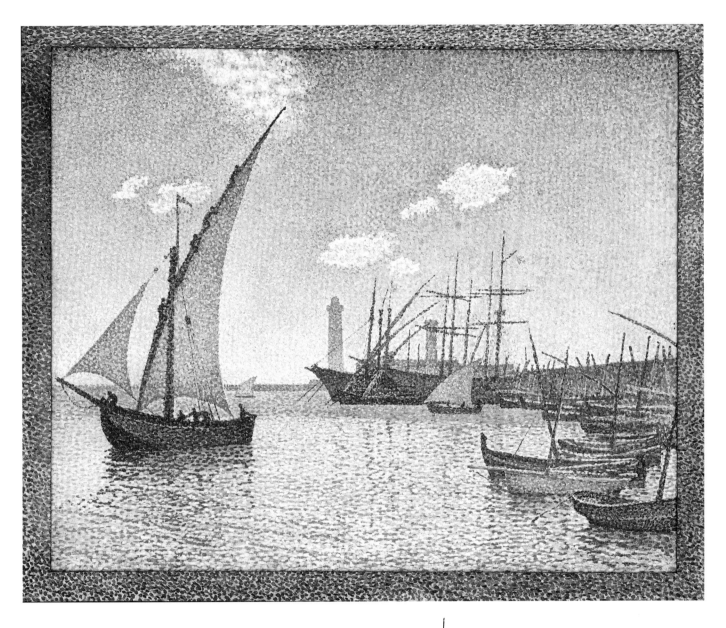

Fig. 30.
Théo van Rysselberghe, *The Port of Sète (Le Port de Cette)*, 1892, oil on canvas, 21½ x 26 inches, The Museum of Modern Art, New York, Estate of John Hay Whitney, 1983

beaut! *
brilliant blues
touched with yellows

49

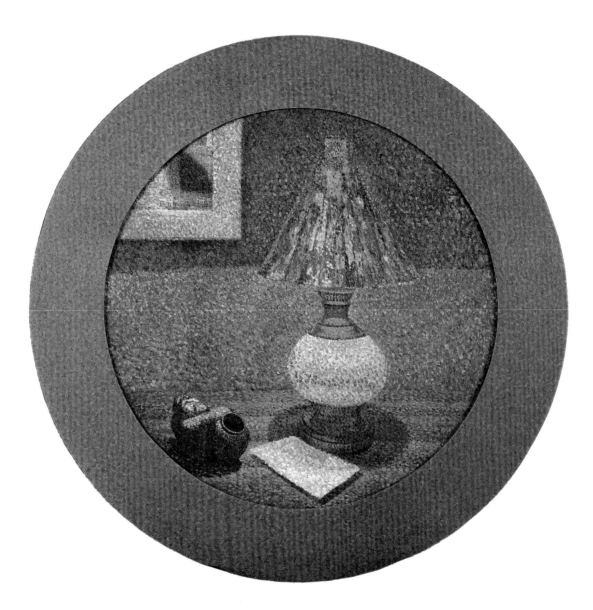

note
from also
n Pontillist style

Fig. 31.
Albert Dubois-Pillet, *Sous la lampe (Under the Lamp)*, c. 1888, oil on canvas, diameter 22½ inches, University of Michigan Museum of Art, Gift of Helmut Stern

Fig. 32.
Henri-Edmond Cross, *Antibes,
après-midi (Antibes in the
Afternoon)*, 1908, oil on canvas,
31⅞ x 39⅜ inches, Scott M.
Black Collection

Phidias for the Parthenon in Athens. Figures were positioned with an exactitude and rigidity that was unknown in Impressionist painting. His *Harbour and Quays at Port-en-Bessin* offers a fabric of geometric shapes (see fig. 2) tightly interlocked over the surface of the canvas. Strong linear elements forcefully hit the left and right edges of the painting, portioning out the height of the canvas in intricate spatial relationships. Seurat placed the woman on the right of the painting at a point two-thirds from the left-hand side of the canvas. The child in the foreground and the chimney of the building positioned above the child form a linear accent that makes a square of the vertical dimension of the canvas from the right edge. The artist is present not only as the object of the child's gaze but also as the author of the insistent geometric control of the scene.

Whether the measured placements outlined in all these paintings were precise and predetermined or were merely intuitive gestures on the part of the artists is not important. What is important is that there is a clear sense of order in most Neo-Impressionist paintings and that that sense of order marks the effect on these artists of one of the prime artistic concerns of their period, the concept of decoration. It is a term easily misinterpreted these days, when it brings to mind interior design more readily than art. But in Paris, in the 1880s and 1890s, *decoration* was used as code for the developing abstraction that would lead to the art of the twentieth century. Other descriptive terms were used from time to time—*synthesis*, for instance—but *decoration* was key, with a rich history that helps to contextualize both the avant-garde qualities of Neo-Impressionism and the more traditional aspects of the movement.

In the minds of artists and the public alike during the nineteenth century, the concept of decorative art was connected with mural painting, specifically Renaissance murals. The Italian fresco tradition of the fifteenth and sixteenth centuries was much respected, and artists as different as Jean-Auguste-Dominique Ingres and Eugène Delacroix tried their hands at mural painting. Claude Monet's last great project, occupying more than twenty years of his career, was a mural decoration depicting water lilies.[2] The Nabis painters were especially interested in decorative projects.[3] One of the most important publicly sponsored commissions of the later nineteenth century in Paris was the vast mural cycle depicting events from the life of Saint Geneviève, the patron saint of the city, on the walls of the Pantheon.[4] Decorative painting was associated with a grand tradition of public commissions on important themes. That is what Roger Marx meant in his 1895 Salon review for the prestigious periodical *Gazette des Beaux-Arts* when he held up mural painting over more commercial easel painting: "Monumental painting presents itself with the prestige of survival, assured to last as long as the walls that support it; it is neither conceived in view of a generation, nor in view of a class; it is dedicated to posterity, it addresses itself to the universal soul."[5]

But by the end of the century the concept of decoration had taken on another connotation related to the particular style of painting best suited for large-scale mural painting. That style was seen to be less naturalistic, less picturesque, less concerned with depicting a view of nature than easel painting was. At base, the reasoning was simple.

enough. Large mural paintings should not dissolve the structural integrity of the walls on which they were placed. Thus, they should not be too naturalistic, especially in terms of spatial recession. Instead, they should restate the flatness of the wall itself and concentrate on decorative rhythms and abstract, simple shapes.[6] But if the concept was simple, the results were no less than earthshaking in the artistic community, for the idea of decoration became intimately associated with the artist's right to deform nature, indeed to disregard nature, for the sake of abstract relationships in and of themselves, independent of visual phenomena, and independent of subject matter.

This is exactly what the young avant-garde critic Albert Aurier—the early champion of both Vincent van Gogh and Paul Gauguin—meant in 1891 when he said that "decorative painting, properly speaking, is the true painting."[7] Aurier included all the subjective, abstract, and symbolist features of Gauguin's work under the rubric of decoration and related his art to the great traditions of the Egyptians, the Greeks, and the Italian "primitives" of the fifteenth century. Indeed, Aurier called for mural commissions for Gauguin. "You have within your midst a decorator of genius," Aurier cried out to his Parisian audience, "walls! walls! give him some walls!"[8] Félix Fénéon, the avant-garde critic who was the sophisticated and eloquent spokesman for Neo-Impressionism, equally touted the abstract qualities of the decorative in the work of Signac. He praised Signac for moving away from earlier Impressionist naturalism to create "an art of grand decorative development, which sacrifices the anecdote to the arabesque, nomenclature to synthesis, the fugitive to the permanent," thus giving nature what he called "an authentic Reality."[9] He meant the same when he lauded the "hieratic and summary drawing" in Seurat's *Grande Jatte*.[10] Years later Henri Matisse would give voice to similar thoughts when he noted, "composition is the art of arranging in a decorative manner the various elements at the painter's disposal for the expression of his feelings."[11] And this, of course, was an echo of the famous dictum of the Nabis painter Maurice Denis, who proclaimed that any picture, no matter what it depicts, was "essentially a plane surface covered with colors assembled in a certain order."[12] In the years before and after the turn of the twentieth century, the concept of the decorative was an essential element in art theory intimately connected with abstract values.

The Neo-Impressionists were in the thick of the decorative impetus in the last decades of the nineteenth century. The scientist Charles Henry, whose theories entranced both Signac and Seurat and the critics Fénéon and Gustave Kahn, who supported them, argued that abstract elements produced emotion by themselves, without direct reference to subject matter.[13] His concept of the "dynamogenic" (joyful) and "inhibitory" (sad) properties of lines, for all of the pseudoscientific jargon, was really about creating a visual language for the artist that is equivalent to the abstract forms of music, about contrast, rhythm, and measure.[14] At the very beginning of his influential *Introduction à une esthétique scientifique,* of 1885, Henry separated art from the natural sciences and isolated its principal means as forms, colors, and, in music, sounds.[15] Henry provided a "scientific" basis for understanding the abstract values of paintings. So had

the earlier Dutch theoretician David-Pierre-Giottin Humbert de Superville, whom both Seurat and Signac admired.[16] Humbert's famous drawing of faces indicating how the direction of lines could yield emotional content was an important impetus for both Henry and the Neo-Impressionists.[17] Both Henry and Humbert offered modern, intellectual treatments of the abstract means at the artist's disposal. They both emphasized the importance of the artist in manipulating nature and, more important, in manipulating the abstract elements of art itself.

Charles Blanc, whose writings were of great significance to artists in France at the end of the nineteenth century, was equally concerned with the artist's ability, indeed, duty, to manage the natural world.[18] Blanc had been government Director of Fine Arts during the years 1848–50, and again from 1870 to 1873. He was the founder of the long-lived *Gazette des Beaux-Arts* and an eloquent spokesman for artists. His *Grammaire des arts du dessin* deeply influenced Seurat and the Neo-Impressionists. In it, Blanc praised art that neglected the details of the real world in favor of a simplicity that provided the opportunity to focus on essentials. He spoke of a work of art as having "style" when things are represented in their "primitive" essence, "disengaged of all insignificant detail," devoid of all but their most salient features.[19] Blanc introduced generations of artists to the work of Humbert de Superville and, most important, was an outspoken proponent of decorative art, which he saw as superior to easel painting.

Signac spoke directly about decoration in his pioneering explanation and history of Neo-Impressionism, *D'Eugène Delacroix au néo-impressionnisme*, first published in 1899.[20] He stated clearly that the first preoccupation of a painter confronting an empty canvas must be to "decide which curves and which arabesques" should cut up the surface, and then what colors and tones should cover it.[21] Elsewhere, he suggested that the Neo-Impressionist technique was particularly suited for decorative projects and noted that painters looked forward to being able to realize grand decorative enterprises, a not too subtle call for commissions.[22] But he further stated that even the small canvases of the Neo-Impressionists were decorative. Quoting the article by Fénéon mentioned above, he noted that Neo-Impressionist paintings were neither studies nor easel pictures but, instead, were decorative, synthetic arabesques.[23] Years later, Signac wrote about the difference between "le pittoresque" and "le pictural."[24] The former term represented for him all the extraneous elements of a painting such as references to history, literary sources, or, worse, sentimentality. But "le pictural" represented all of the plastic forms at the painter's command, such as technique and the aesthetic conceptions of order and harmony. In essence, he spoke of the triumph of abstraction over realism, the very underpinning of modern art. The concept of the decorative was very weighty indeed for the Neo-Impressionist painters because it separated them from all the illusionistic, realistic manners of the past. It made the Neo-Impressionists modern. Yet at the same time, it also connected them with the past, and their balancing act between the eternal verities of tradition and the avant-garde needs elaboration here.

Signac was particularly concerned with connecting Neo-Impressionism with

tradition. His classic study of the movement, *D'Eugène Delacroix au néo-impressionnisme*, after all, was an attempt to create a history of the movement that related it to the past. Elsewhere he was at pains to connect Neo-Impressionist artists with tradition through the rules of composition and laws of harmony to which they adhered and which had been used either directly or intuitively by artists from ancient Greece to the nineteenth century.[25] Speaking of the "eternal rules" of composition, Signac mentioned two artists who shared Seurat's concern for structure in painting: Nicolas Poussin and Pierre Puvis de Chavannes.[26] Of Puvis de Chavannes we will say more shortly, but Poussin was, of course, the very model of French classical style. His concept of emotional "modes" must be seen as the antecedent of any nineteenth-century thought on the emotive quality of abstract elements in painting. Poussin represented the best of the past, the solid authority of Tradition, to generations of French artists. The sober, carefully composed, and structured paintings of this seventeenth-century master provided the model for instruction in the French Academy right through the nineteenth century, and they offer remarkable similarities to the composed abstractions we have already noted in Neo-Impressionist painting.[27] *His Landscape with Saint John on Patmos* (fig. 33), of 1640, is an excellent example. For all its atmospheric sense of depth, the painting insistently reveals its abstract two-dimensional structure. The prominent obelisk in the middle distance marks a vertical line that pierces the horizontal dimension of the canvas at a golden section. The top of the plinth in the left foreground creates a horizontal axis that neatly intersects with the vertical of the obelisk and marks a golden section of the height of the painting. The column base and the small tree above it, as well as the larger tree, create a vertical accent centered on a line that marks a square of the canvas. If Neo-Impressionist abstraction is related to modernism—and it certainly was modern—it was also related to a desire to return to the art of the past.

The Impressionists, during the classic phase of their plein-air style, had avoided any reference to the traditions of past art. For instance, although Monet had a pass to paint in the Louvre while he was an art student, rather than copying old masters like Poussin, he walked straight through the galleries and set up his easel on a balcony to paint the landscape of Paris.[28] But Seurat was interested in reviving tradition while at the same time modernizing it. As an art student, he was deeply influenced by Poussin and he continued to structure his paintings in a Poussinesque manner throughout his career. Paul Cézanne is famous for his often-quoted desire to bring a solidity based on

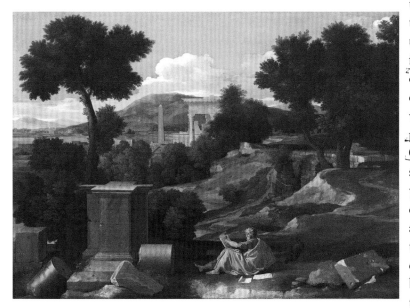

Fig. 33.
Nicolas Poussin (France, 1594–1665), *Landscape with Saint John on Patmos*, 1640, oil on canvas, 39½ x 53¾ inches, The Art Institute of Chicago, A. A. Munger Collection, 1930.500

Fig. 34.
Pierre Puvis de Chavannes
(France, 1824–1898), *Doux pays
(Pleasant Land)*, 1882, oil on
canvas, 90½ x 118 inches,
Musée Bonnat, Bayonne, France,
collection Bonnat

Fig. 35.
Maximilien Luce, *Éragny, les bords de l'Epte (Éragny, on the Banks of the Epte)*, 1899, oil on canvas, 32 x 45¾ inches, Scott M. Black Collection

the structural principles of past art to Impressionist painting, yet Seurat was equally concerned with that enterprise.[29] The critic Téodor de Wyzewa, who knew Seurat well, said that Seurat's soul was connected to the past and that he was kin to such artists as Leonardo, Albrecht Dürer, and Poussin.[30] Indeed, all of the theorists favored by Seurat and his friends championed the art of the past. Of course they differed radically from conservative academicians in their modernist emphasis, but the fact that they returned to older art as a model was a significant break from Impressionist landscape painting.

Henry suggested that all the traditional formulas of art from the past were basically the same. He spoke of the order and "immutable laws" that were set down in past art and linked his own scientific ideas about aesthetics with those same principles. Humbert de Superville loved the art of the past and was particularly fond of the art of Egypt and the early Italian Renaissance. David Sutter, whose writings on aesthetics influenced Seurat, praised the idealism and intellectual appeal of Greek art and the rational French art of Poussin and Claude Lorrain.[31] As much as anyone else, Blanc urged young artists to look to the art of the past. Blanc had edited, and wrote most of, a multivolume study of art history that was the source of many of the anecdotes and much of the information about past art circulating in artistic circles in Paris in the last decades of the nineteenth century.[32] He was particularly fond of the mural painting tradition. When he was Director of Fine Arts, Blanc had ambitiously sought to create a museum of copies of all the important works of past art not already in French collections. Among these were copies of Piero della Francesca's mural cycle at Arezzo that hung in the Ecole des Beaux-Arts when Seurat was a student there.[33] Blanc was an ardent republican who believed that the new French Third Republic could be well served by a revival of mural painting, and indeed it was. The republic, whose leaders understood the value of both public commissions and the link to the art of the past, enthusiastically patronized mural painting. And no artist was more important to the revival of mural painting than Pierre Puvis de Chavannes.

Few art historians today would dispute the influence of Puvis de Chavannes on Seurat and the Neo-Impressionists.[34] Yet Puvis's control of the Parisian art public during the last two decades of the nineteenth century is often underestimated. No artist was better known, none more widely admired and more hotly debated. Signac, for one, continually made reference to Puvis in his writings, seeking solace in his murals, lamenting the master's death in 1898.[35] Puvis de Chavannes offered a revival of the grand tradition of mural painting, while at the same time he was criticized for his abstractions. Although he painted on canvas, his huge compositions were almost always made to be installed in public places, glued to the walls as permanent murals. Before his paintings were sent to such locations as Lyon, Amiens, and Rouen, the Parisian audience had a chance to see them. Year after year his massive canvases were shown at the annual Salon exhibitions, where their sheer size was enough to attract attention. Salon reviews quite often began with long, adoring descriptions of Puvis's paintings.[36] His work was virtually impossible to avoid.

Paintings such as *Pleasant Land*, of 1882 (fig. 34), perfectly demonstrate Puvis de

Chavannes's idealized, classicized, abstract style. The figures evoke an ancient, timeless past, and the canvas is infused with a sense of dignity, sobriety, and calm that marks all of the artist's mural decorations. Colors are muted and flattened, and figures and ground are simplified into regular abstract shapes. Puvis's many defenders loved to show how they understood that his synthesis, his abstraction from reality, was based on the needs of a mural aesthetic. The term *decorative* appeared over and over again in writing about Puvis de Chavannes and it became associated in the public view with the artist's duty to modify the natural world to create idealized, perfected paintings. The Neo-Impressionists recognized this and some even attempted to create murals with idealized themes more or less in imitation of Puvis de Chavannes. If the figural arrangements in Cross's *Excursion* (see fig. 18) seem based on Antoine Watteau's *Return from Cythera* (Musée du Louvre, Paris), the painting has an idealized, utopian mood that is closer to Puvis's works. The main compositional motif, consisting of the couple at the left and the large tree behind them, is centered on a line that would square the vertical dimension of the canvas. The figures are stiff and frozen in the manner of Puvis, not lyrical and fluid, as Watteau would have made them. Maximilien Luce's *Éragny, on the Banks of the Epte*, of 1899 (fig. 35), is clearly modeled on arcadian prototypes by Puvis de Chavannes. Of course, the paintings by both Cross and Luce are more concerned with modernity—depicting figures in modern dress using modern divisionist technique—than any of Puvis's murals, but the debt is clear enough. Seurat's *Bathers at Asnières*, which Robert Herbert has related to Puvis's *Pleasant Land*, was the first example of this kind of borrowing among young modernist artists and was certainly a model, along with his *Grande Jatte*, for later Neo-Impressionists.[37] But the Neo-Impressionists took the decorative abstractions of Puvis's figure paintings beyond the idealized figural mode. They equally applied decorative lessons learned from him in their landscape paintings. Van Rysselberghe's *La Régate* (see fig. 29), is a fine example. Many of the abstract features of this painting noted earlier can be read as an homage to Puvis de Chavannes. The flattened shape of the sailboats; the abstract patterns of land, sky, and water; the measuring out of space with vertical and horizontal elements—these are all reminiscent of *Pleasant Land*.

Today such comparisons with Puvis de Chavannes are not as obvious as they were in the late nineteenth century. Nowadays the bright palette and divisionist technique of Van Rysselberghe and the Neo-Impressionists are the focus of attention. One has to learn to see the influence of Puvis de Chavannes in Neo-Impressionist painting, whereas the modernist, Impressionist background is obvious to the most casual observer. Nevertheless, Neo-Impressionist style was deeply indebted to Puvis. He was very much the darling of the Third Republic, and any artist growing up during the 1880s and 1890s could not escape his pervasive influence. And we would do well to remember that Paul Durand-Ruel, the same dealer who championed the Impressionists, handled Puvis's work for a time.

Contemporary observers had no trouble seeing the connection between Puvis de Chavannes and the Neo-Impressionists. That is why Kahn began a review of Puvis's major exhibition at the Durand-Ruel gallery by stating that the same words—such

as "synthesis," "hieraticism," and "harmony"—characterized both Puvis and Neo-Impressionism.[38] That is why Fénéon called Seurat a "modernizing Puvis."[39] And that is why Signac used Puvis's murals at Amiens as a model that the Neo-Impressionists could enliven with their brilliant color in their decorative paintings.[40] To be sure, the avant-garde artists of the 1880s and 1890s did not copy Puvis de Chavannes; they used his work, modified it to suit their purposes. But the very fact that they went to Puvis at all, at a time when artists like Monet had rejected any art that smacked of tradition, was significant. Puvis de Chavannes offered an attractive, highly acceptable path back to tradition for young artists and critics alike, and it is impossible to understand the art of the last decades of the nineteenth century without understanding his attraction. The appeal was not in his subject matter but in his decorative aesthetic and how he achieved a nobility reminiscent of the art of the past through that aesthetic.

No account of the significance of the decorative aesthetic in the last decade of the nineteenth century would be complete without some reference to Art Nouveau. All about a modern revival of the decorative arts, a love of design for its own sake, Art Nouveau presented a youthful, fresh look that swept Europe in the years around the turn of the twentieth century.[41] To be sure, Art Nouveau was less of an influence than the decorative aesthetic of a major figure such as Puvis de Chavannes. But when Signac speaks of decorative rhythms and arabesques, as he does so often in his theoretical writings, one is reminded of the sinuous Art Nouveau decorative flourishes that permeated every aspect of French design during much of the time that he was working. From 1895 through the first years of the twentieth century, the Neo-Impressionist painters would have had daily contact with Art Nouveau in architecture, furniture, and graphic design.

If Jules Cheret's brightly colored and dynamic posters of circus and theatrical subjects can be said to exemplify Art Nouveau design, then Seurat certainly was influenced by Art Nouveau. Several works by Seurat—*The Chahut* (Kröller-Müller Museum, Otterlo, The Netherlands) and *The Circus* (Musée d'Orsay, Paris) are good examples—show the influence of Cheret's brilliant color and characteristic drawing style.[42] Signac was associated with Art Nouveau in more than one way. He was a close friend of Henry van de Velde, the Belgian designer central to the early development of Art Nouveau style. Signac was also literally ensconced in Art Nouveau for a time. In the spring of 1897 he moved into Hector Guimard's early masterwork of Art Nouveau architecture, the Castel Béranger in Paris.[43] Signac wrote a review of an album of hand-colored plates published by Guimard reproducing various details and views of the building and took advantage of the opportunity to offer his opinion of the structure.[44] He praised the audacity of the Castel Béranger and, in a bow to Charles Henry, delighted in the "dynamogenic arabesques" of the design, while at the same time noting too brusque changes in rhythm and some "inhibitory measures." Signac appreciated the logic of the decoration, noting, for instance, how the arabesque design of the carpet on the staircase was meant to give a sensation of uplift, rising to the upper floors. He felt that

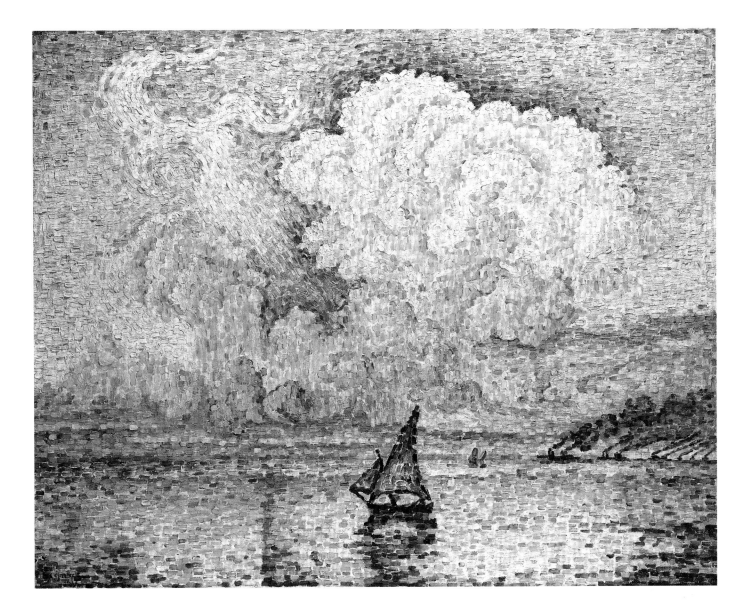

Fig. 36.
Paul Signac, *Antibes, le nuage rose (Antibes, the Pink Cloud)*, 1916, oil on canvas, 28 x 35 inches, Scott M. Black Collection

Fig. 37.
View of an elaborate ironwork
doorway on No. 14, Rue La
Fontaine, Paris, designed by
Hector Guimard (1867–1942),
1897–98. Le Castel-Béranger,
Paris, France

Guimard had a great career ahead of him and that he would be the designer of the "joyful house" of the future. On the basis of this article at least, Signac seems to have very much appreciated Art Nouveau style.

At the same time, as Philippe Thiébault has shown, Signac had real reservations about Art Nouveau.[45] He did not like the way that Art Nouveau architects made decorative paintings subservient to overall architectural schemes, and in private letters he complained about the "overly flashy" quality of Guimard's designs. When he furnished his own apartment in the Castel Béranger, he had Van Rysselberghe execute the designs in a style related more to the Arts and Crafts movement than to Art Nouveau. He owned no major furniture by his friend Van de Velde, although a few small objects by the designer did grace Signac's home. In truth, as Debora Silverman has noted, Neo-Impressionists were much more sympathetic to Belgian manifestations of Art Nouveau, with their leftist attitude, than to its French practitioners.[46]

But finally it is in the paintings that one comes to terms with the relationship between Art Nouveau and Neo-Impressionism. And in paintings such as Seurat's *The Circus* and *The Chahut*, and Signac's *Women at the Well* (private collection) and *Place des Lices, St. Tropez* (Carnegie Institute, Museum of Art, Pittsburgh), it is tempting to see the decorative rhythms of Art Nouveau design—a little Toulouse-Lautrec here, a little Hector Guimard there, so to speak. The Neo-Impressionists were surrounded with Art Nouveau, and one would be surprised if the rhythms of the modern style did not occasionally show up in their work, intentionally or not.

What then might we make of a painting like Signac's *Antibes, le nuage rose* (*Antibes, the Pink Cloud*), of 1916 (fig. 36), in which the flat bands of color in the lower part of the painting are so visually distinct from the dynamically curvilinear upper section? That cloud swaying up the left side seems influenced by the sinuous arabesques of Art Nouveau design. In a letter to Fénéon, Signac likened the cloud to Loie Fuller, the dancer so often portrayed in Art Nouveau posters.[47] If it is a reference to Art Nouveau, might we conclude that it is a reminiscence by the fifty-three-year-old artist on a style of his youth? Could that cloud relate in a general way to the joyful style of Art Nouveau, or even more specifically to the upward-rising designs on the stairway carpet of the Castel Béranger that the artist walked over so many times? Françoise Cachin long ago published a photograph of the elaborately sweeping patterns of the wrought-iron gate of the Castel Béranger (fig. 37) as evidence of a relationship between Signac's work and Art Nouveau design.[48] The connection seems remarkably appropriate now in comparison with *Antibes, le nuage rose*. Do we go too far in suggesting that this is a painting about light and joy overcoming darkness, about hope during the darkest days of World War I? We know that Signac was deeply affected by the war.[49] We also know that he was obsessed with the emotional qualities of lines, shapes, and decorative arabesques. What, might we ask, was the emotion that the middle-aged theorist of Neo-Impressionism believed he was investing in this intriguing painting? Emotions are notoriously difficult to pin down, and sometimes visual referents are equally difficult to ascertain. But both joy and Art

Nouveau seem to be working their way up the left-hand side of *Antibes, le nuage rose*, in clear opposition to the dark smoke coming from those menacing warships, the "black squadron" as Signac put it, on the horizon at the right.[50]

The art of representation was undergoing major changes in France at the end of the nineteenth century. Emphasis on subject matter was giving way to emphasis on the abstract elements of line, color, and shape—the very things that separated painting from the other arts. The concept of decoration played a major role in the transition. Artists as widely different as Monet, Cézanne, Gauguin, Van Gogh, and the Nabis painters were caught up in the concern for the decorative. Signac, in many ways the voice of Neo-Impressionism, held the term in high regard throughout his life. The decorative aesthetic, as much as color, dominated the enterprise of the Neo-Impressionists, and it should never be far from our thoughts when contemplating their complexly structured compositions.

Notes

My thanks to both Marianne Doezema and John Varriano for offering advice on early versions of this essay.

1. The golden section is a single division of a line so that the relationship between the smaller part and the larger part is exactly the same as the proportional relationship between the larger part and the entire line. That proportional relationship is .617. Claims for its use in art abound, from studies of Greek pottery, to Renaissance painting, to Seurat. See my "Seurat et ses amis de l'École des Beaux-Arts," *Gazette des Beaux-Arts* 114 (October 1989): 153–68, for suggestions that Seurat used the proportion. See Roger Herz-Fischler, "An Examination of Claims Concerning Seurat and 'the Golden Number,'" *Gazette des Beaux-Arts* 101 (March 1983): 109–12, for an opposing view.

2. See, for example, Charles Stuckey, *Claude Monet, 1840–1926*, exh. cat. (Chicago: The Art Institute of Chicago, 1995), pp. 16–17.

3. The definitive source on Nabis decoration is Gloria Groom, *Beyond the Easel: Decorative Paintings by Bonnard, Vuillard, Denis, and Roussel, 1890–1930*, exh. cat. (Chicago: The Art Institute of Chicago, 2001).

4. Patricia Mainardi has examined the significance of large-scale mural projects during this period. See her *The End of the Salon: Art and the State in the Early Third Republic* (New York: Cambridge University Press, 1993), pp. 57–59. For more on the Pantheon murals, see Charles Philippe, marquis de Chennevières, *Souvenirs d'un directeur des Beaux-Arts* (reprint; Paris: Arthena, Association pour la diffusion de l'Histoire de l'Art, 1979), and Pierre Vaisse, "La Peinture monumentale au Panthéon sous la IIIe République," in Caisse nationale des monuments historiques et des sites en France and Centre canadien d'architecture, *Le Panthéon, symbole des revolutions: de l'église de la nation au temple des grands hommes*, exh. cat. (Paris: Picard, 1989), pp. 252–58.

5. Roger Marx, "Les Salons de 1895," *Gazette des Beaux-Arts 38* (June 1895): 442.

6. Aimée Brown Price has shown that Henri Delaborde had pointed out the difference between mural painting and easel painting as early as 1859. See her *Pierre Puvis de Chavannes*, exh. cat. (Amsterdam: Van Gogh Museum, 1994), pp. 49–51 and 53 n. 39.

7. Albert Aurier, "Le Symbolisme en peinture, Paul Gauguin," *Mercure de France*, March 1891, reprinted in Aurier, *Oeuvres posthumes* (Paris: Mercure de France, 1893), p. 216.

8. Aurier, 1893, p. 219.

9. Félix Fénéon, "Signac," *Les Hommes d'aujourd'hui*, May 1890, reprinted in Fénéon, *Oeuvres plus que complètes*, ed. Joan U. Halperin (Geneva: Librairie Droz, 1970), p. 175.

10. Félix Fénéon, *Les Impressionnistes en 1886* (Paris: La Vogue, 1886), reprinted in Fénéon, 1970, p. 37.

11. Henri Matisse, "Notes d'un peintre," *La Grande Revue*, December 1908, translated and quoted in Herschel B. Chipp, *Theories of Modern Art* (Berkeley and Los Angeles: University of California Press, 1970), p. 132.

12. Originally published in the Parisian periodical *Art et critique*, August 1890, translated and quoted in Chipp, 1970, p. 94.

13. A good recent source about the influence of Charles Henry on the Neo-Impressionists is Michael Zimmermann, *Seurat and the Art Theory of His Time* (Antwerp: Fonds Mercator, 1991). Also see Robert Herbert, with Françoise Cachin, Anne Distel, Susan Alyson Stein, and Gary Tinterow, *Georges Seurat, 1859–1891*, exh. cat. (New York: The Metropolitan Museum of Art, 1991), pp. 391–93. Also see William Innes Homer, *Seurat and the Science of Painting* (Cambridge, Mass.: The MIT Press, 1964), and Jose Argüelles's idiosyncratic *Charles Henry and the Formation of a Psycho-physical Aesthetic* (Chicago: University of Chicago Press, 1972).

14. See Charles Henry, *Cercle chromatique de M. Charles Henry présentant tous les compléments et toutes les harmonies de couleurs, avec une introduction sur la théorie générale de la dynamogénie, autrement dit: du contraste, du rythme et de la mesure* (Paris: C. Verdin, 1888).

15. Charles Henry, "Introduction à une esthétique scientifique," *La Revue contemporaine* 2 (May–August 1885): 441–69.

16. David-Pierre-Giottin Humbert de Superville was known most importantly among artists for his *Essai sur les signes inconditionnels dans l'art* (Leiden: C. C. Van der Hoek, 1827). Seurat and Signac probably knew of Humbert de Superville through the writings of Charles Blanc. See Herbert et al., 1991, pp. 386–87.

17. The diagram is reproduced in many texts. See, for instance, Herbert et al., 1991, p. 385.

18. On Blanc, see Misook Song, *Art Theories of Charles Blanc, 1813–1882* (Ann Arbor, Mich.: UMI Research Press, 1984). Also see Zimmermann, 1991, pp. 17–58.

19. Charles Blanc, *Grammaire des arts du dessin: architecture, sculpture, peinture* (Paris: Librairie Renouard, 1883), p. 20. The *Grammaire* was originally published in the *Gazette des Beaux-Arts*, 1860–66, and republished many times throughout the remainder of the nineteenth century.

20. Paul Signac, *D'Eugène Delacroix au néo-impressionnisme* (Paris: Éditions de La Revue blanche, 1899). The following quotations come from the recent paperback edition, Paris: Collection Savoir Hermann, 1978.

21. Signac, 1978, p. 103.

22. Signac, 1978, pp. 124–25.

23. Signac, 1978, p. 126.

24. Paul Signac, "Le Sujet en peinture," first published in the *Encyclopédie française*, 1935, and reprinted in Signac, 1978, pp. 174–90.

25. Signac, "Le Sujet en peinture," in Signac, 1978, p. 185. Signac specifically mentions the golden section in this passage.

26. Signac, "Le Sujet en peinture," in Signac, 1978, p. 177.

27. Interestingly, Sir Kenneth Clark long ago suggested that without understanding Poussin's methods for giving order to landscape one could not understand Seurat or, for that matter, Cézanne. He spoke of the architectural effects of "horizontals and verticals and their rhythmic relations to one another," and noted that Poussin "often disposed them according to the so-called golden section." Kenneth Clark, *Landscape into Art* (1949; Boston: Beacon Press, 1961), p. 66. The literature on Poussin is extensive. Recently Margaretha Lagerlöf, *Ideal Landscape: Annibale Carracci, Nicolas Poussin and Claude Lorrain* (New Haven and London: Yale University Press, 1990), offers excellent insight into the nature of idealized landscape painting.

28. See Joel Isaacson, "Monet's Views of Paris," *Allen Memorial Art Museum Bulletin* 24 (fall 1966): 5–22.

29. There are many comments in the literature on Seurat linking him to the tradition of Poussin. A good recent treatment is Herbert et al. Richard Thomson, *Seurat* (Oxford: Phaidon Press, 1985), p. 87, demonstrates the many similarities between Seurat's *Bathers at Asnières* and Poussin's *Finding of Moses* (Musée du Louvre, Paris), which had been particularly praised by Charles Blanc.

30. Téodor de Wyzewa, "Georges Seurat," *L'Art dans les deux mondes* 22 (April 18, 1891): 263–64.

31. On Sutter and Seurat, see Homer, 1964, and Herbert et al., 1991, pp. 387–88.

32. Charles Blanc, *Histoire des peintres de toutes les écoles*, 14 vols. (Paris: Librairie Renouard, 1861–76).

33. See Zimmermann, 1991, p. 32.

34. Zimmermann, 1991, offers a good analysis of the relationship. Price, 1994, is the best recent general treatment of the artist and offers an excellent bibliography.

35. John Rewald, "Extraits du journal inédit de Paul Signac," *Gazette des Beaux-Arts* 39 (January–June 1952): 283, and 42 (July–December 1953): 37.

36. My "Puvis de Chavannes and the Parisian Daily Press," *Apollo* 149 (February 1999): 3–10, is an attempt to deal with the vast body of nineteenth-century Salon reviews about Puvis de Chavannes.

37. Robert Herbert, "Seurat and Puvis de Chavannes," *Yale University Art Gallery Bulletin* 25 (October 1959): 22–29. This is updated in Herbert et al., 1991, pp. 147–51, where the author notes how Puvis fulfilled the ideals of Charles Blanc.

38. Gustave Kahn, "Exposition Puvis de Chavannes," *La Revue indépendante* 6 (January 1888): 142–46.

39. Fénéon, "VII Exposition Impressionniste," originally published in *La Vogue*, June 1886, and reprinted in Fénéon, 1970, p. 37.

40. Signac, 1978, pp. 125–26.

41. The best source on Art Nouveau, contextualizing the movement in relation to politics and society in general, is Debora L. Silverman, *Art Nouveau in Fin-de-Siècle France* (Berkeley and Los Angeles: University of California Press, 1989).

42. See, for example, Herbert et al., 1991, pp. 340–45, 360–64.

43. On the Castel Béranger, see Maurice Rheims, *Hector Guimard* (New York: Harry N. Abrams, 1985), pp. 30–50.

44. Paul Signac, "Hector Guimard: L'Art dans l'habitation moderne, le Castel Béranger," *La Revue blanche* 8 (February 1899): 317–19.

45. Philippe Thiébault, "Art Nouveau et néo-impressionnisme: les ateliers de Signac," *Revue de l'art* 92 (1991): 72–78.

46. Silverman, 1989, pp. 212–14.

47. Signac's letter is cited in Marina Ferretti-Bocquillon et al., *Signac, 1863-1935*, exh. cat. (New York: The Metropolitan Museum of Art, 2001), pp. 252–54.

48. Françoise Cachin, *Paul Signac* (Paris: Bibliothèque des Arts, 1971), p. 69.

49. Marie-Thérèse Lemoyne mentioned that fact in reference to this very painting, suggesting that Signac found solace in his paintings. Marie-Thérèse Lemoyne, ed., *Signac*, exh. cat. (Paris: Musée du Louvre, 1963), p. 77.

50. Ferretti-Bocquillon et al., 2001, p. 252.

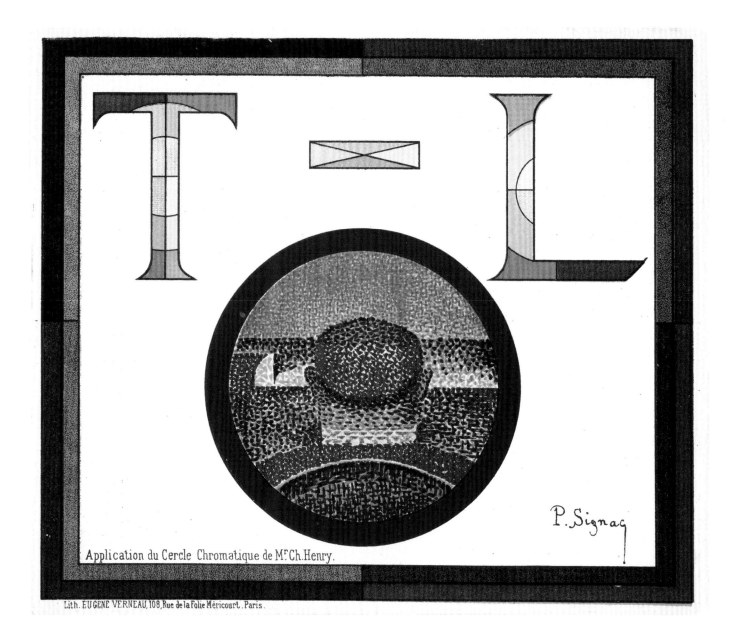

Fig. 38.
Paul Signac, *Application of the Chromatic Circle of Mr. Charles Henry*, 1888, lithograph, 6 x 7 inches, Courtesy of the Fogg Art Museum, Harvard University Art Museums, Anonymous Loan in honor of Virginia H. Deknatel

Points and Pixels: Looking at Neo-Impressionism and Digital Art

Sabrina DeTurk

"At an exhibition of Neo-Impressionism in 1893, a woman peered over the entrance turnstile at the paintings inside, while debating whether or not to pay the modest fee to one of the painters seated at the cash box. 'Were these done by machine, Monsieur?' she asked. 'No, Madame,' he calmly replied, 'they were done by hand.'"[1] While we cannot know whether this exchange recounted by Robert Herbert truly took place, the unease to which it alludes is instructive in considering the topic of this essay—possible intersections between Neo-Impressionism and digital art. For both art forms connect to science and technology in ways that can be profoundly unsettling for their viewers. In the hundred or more years since the inception of the Neo-Impressionist movement, we have become accustomed to the points of color employed by these artists in the creation of their images; however, it is worth recalling that the original viewers of these works were often taken aback by the artists' reliance on scientific theories of light and color as the basis for their paintings. Likewise, contemporary viewers of digital art are sometimes unnerved by the combination of technology and aesthetics present in the works. We prefer to link the work of art to the artist's physical act of production, and the insertion of a machine—the computer—into that process destabilizes our notions of what it means to create a work of art.[2]

In Gary Clark's series *Postcards from the Digital Highway*, for example, the artist makes use of fractal-generating[3] software to create fictive landscapes which are then further manipulated within the computer before being issued as prints (fig. 39). The computer and its programs are essential to this production—although fractals occur in nature, they cannot be re-created by the human hand—and yet, the artistic vision of the artist is also a necessary component of the work and serves to direct the final product. This fusion of aesthetic vision and technology may be fruitfully linked to the work of the Neo-Impressionists, who, despite their dependence on science for the creation of their

works, never abandoned the aesthetic impulse nor lost their awareness that the painter's eye is of paramount importance in the creation of a successful image. As the nineteenth-century critic Félix Fénéon wrote, "These painters are accused of subordinating art to science. They only make use of scientific facts to direct and perfect the education of their eye and to control the exactness of their vision. Professor O. N. Rood has furnished them with precious discoveries. . . . But Mr. X can read optical treatises forever and he will never paint *La Grande Jatte*" (see fig. 49).[4] Georges Seurat, Paul Signac, Camille Pissarro, and the other Neo-Impressionists all utilized a knowledge of scientific theory and of mechanical processes (those employed in the production of color prints, for example) to guide their artistic explorations. Digital artists use technology to make their art—often to assist them in producing work that could not be created by conventional methods. But neither the Neo-Impressionists nor contemporary digital artists have denied that artistic vision and creativity are at the root of successful artistic practice and that serendipity, taste, and intuition play key roles in the creative process. A consideration of the points of connection between these two groups of avant-garde artists may illuminate the ways in which art and science or technology can be fruitfully joined in the service of art making.

An exploration of the connections between digital art and Neo-Impressionism requires first an understanding of the characteristics of each artistic style, particularly as each relates to science and technology. The term *digital art* refers generally to art created on, or influenced by, the computer. The range of digital art is expansive—from digitally created sculpture, to room-size installations, to computer-rendered drawings, to Web-based works of art. In this essay, I will focus on one category of digital art, digital prints. Digital prints have a particular resonance with Neo-Impressionism on several levels and these will be explored here. Digital prints bear a superficial similarity to Neo-Impressionism

Fig. 39.
Gary Clark, *Postcards from the Digital Highway*, 1997, IRIS print, 20 x 45 inches, Courtesy of Silicon Gallery Fine Art Prints

in their reliance on the dot or point, though these points are seldom seen in the final printed product. An exception can be found in the work of Jonathan Lewis, whose *Composition in Red, Yellow, and Blue (Mondrian)* reveals its subject at the level of the pixel—the point of digital imagery (fig. 40). The pixel is the smallest unit of color found in a digital image and also describes the resolution of the image on-screen and when printed. For example, a computer screen might typically have a resolution of 800x600 pixels, meaning that the screen displays 800 pixels across and 600 pixels down. Each pixel represents a square of color information—when you see a complex image, such as a photograph, on a computer screen you are seeing those pixels set next to one another in such a way that the color seems continuous and realistic. If the screen image were magnified to the level at which individual pixels become noticeable, it would be apparent that on the computer the photograph is represented by squares of color of varying hue and intensity—the effect seen in Lewis's image. Lewis created *Composition in Red, Yellow, and Blue (Mondrian)* by digitizing (through scanning) a reproduction of Piet Mondrian's painting, magnifying the image so that the pixels were visible, and then cropping the image to obtain the desired circular section presented here. The resulting print succeeds in abstracting the abstract and also calls to mind the points employed by the Neo-Impressionists. The rhythmically arranged blue of Lewis's print recalls the shimmer of landscape and sky in such Neo-Impressionist images as Paul Signac's painting of 1890 *Port of Saint-Cast, Opus 209* (see cover) and André Léveillé's *Le Retour des moissonneurs (The Return of the Harvesters)* (fig. 41).

That rhythmic or shimmering color was an effect sought by the Neo-Impressionists was articulated in the writings of Signac, the movement's most theoretical proponent. Signac related the process of *divisionism* (the term preferred by the Neo-Impressionists over the initially employed *pointillism*) to the art of the musician, writing:

The painter has played on his keyboard of color, just as a composer handles the diverse instruments to orchestrate a symphony: he has modified the rhythms and measures to suit his wishes, attenuated one element while enhancing

Fig. 40.
Jonathan Lewis, *Composition in Red, Yellow, and Blue (Mondrian),* from the series *Heavenly Bodies*, 2000, IRIS print, 33 x 33 inches, Courtesy of Silicon Gallery Fine Art Prints

Fig. 41.
André Léveillé, *Le Retour des moissonneurs (The Return of the Harvesters)*, undated, oil on canvas, 15 x 20½ inches, Walter F. Brown Collection

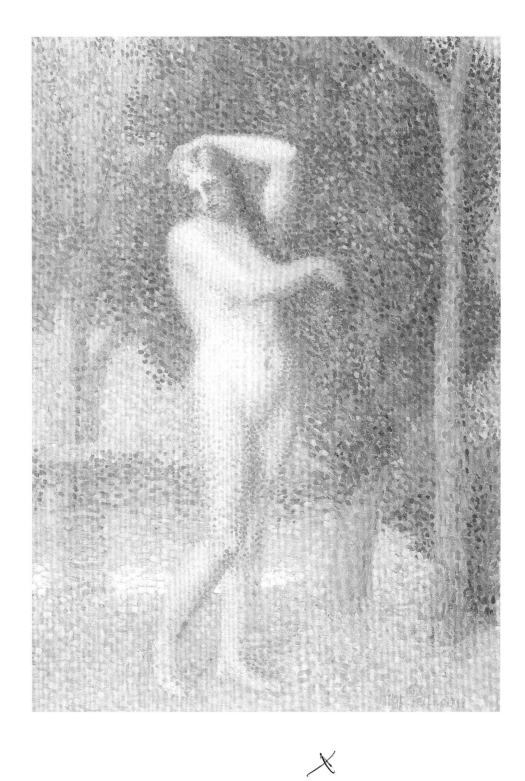

Fig. 42.
Hippolyte Petitjean, *Baigneuse au bord de la rivière (Bather at the River's Edge)*, 1890, oil on canvas, 21⅞ x 15⅛ inches, Walter F. Brown Collection

another, and produced infinite modulations of a particular gradation. As he gives himself up to the joy of directing the interplay and strife of the seven colors of the prism, he will be like a musician multiplying the seven notes of the scale to produce his melody.[5]

The Neo-Impressionists worked within a limited palette that excluded black and earth colors. The arrangement of the pigments was structured so that colors were placed on the canvas adjacent to their pigmentary opposites (red with green, blue with orange, and yellow with violet). This arrangement can be seen clearly in the 1890 *Baigneuse au bord de la rivière* (*Bather at the River's Edge*) of Hippolyte Petitjean (1854–1929) (fig. 42). What is equally clear from this image is that the adjacency of opposites did not always entail the placement of a stroke of one color next to its pigmentary opposite (as in the blue and orange strokes of the forest floor) but could apply to the adjacency of entire areas of color, for example, the reddish tones of the nude figure set against that green of the trees. Moreover, as Ellen Lee notes, "The artist was not even restricted to one shade of green but could vary both hue and value to suggest the gradations that exist in any field of green grass. These gradations, or orchestrations of related hues, are the other element [in addition to complementary pairings] of Neo-Impressionist harmonies and they contribute to the flickering of the painted surface."[6]

Thus the Neo-Impressionists' interest in color went beyond a strict adherence to the placement of complementary pigments on the canvas and extended to an exploration of how the disposition and variation of those pigments created the flickering luminosity that was a goal of many Neo-Impressionist paintings. Attaining that desired effect required an understanding of the basic color principles outlined by such scientists as Ogden Rood and Charles Henry, but the artists equally needed to rely on their keen observation of nature and an ability to manipulate the rules of color theory to achieve the correct optical effects on a painted surface. Movement, manipulation, and mechanics are all relevant to the work of Thomas Porett, whose *TimeMotion* #6 fuses digitally photographed images to create a rhythmic display of light and color (fig. 43). The

Fig. 43.
Thomas Porett, *TimeMotion #6*, 2000, IRIS print, 36 x 10¾ inches, Courtesy of Silicon Gallery Fine Art Prints

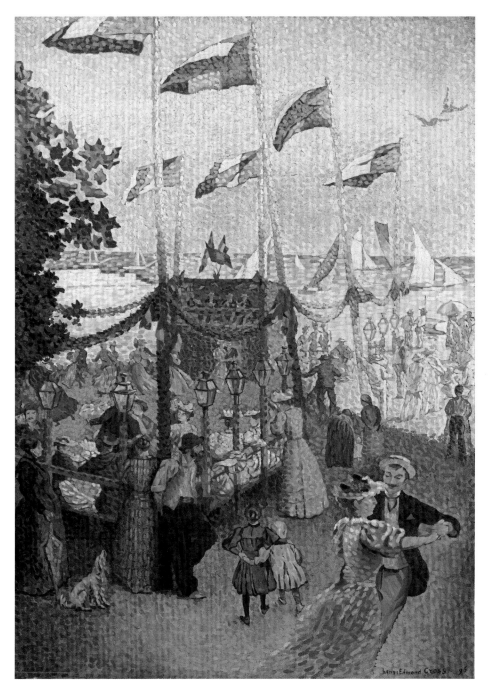

Fig. 44.
Henri-Edmond Cross, *At the Fair*, 1896, oil on canvas, 36⅜ x 25¾ inches, Toledo Museum of Art; Purchased with funds from the Libbey Endowment, Gift of Edward Drummond Libbey, 1951.308

moving figures of Porett's image recall the dancing couple in the lower right corner of Henri-Edmond Cross's *At the Fair* from 1896 (fig. 44). However, while Cross applied theoretical principles of divisionism to achieve the sense of activity in his image, Porett used the contemporary technique of digital photography and computerized image manipulation to create his friezelike print, with its neon lights and gaudy colors. The hot pink, turquoise, and lemon yellow of Cross's painting highlight the joyous and carefree atmosphere of the fair; in Porett's image as well, the light and colors captured by the artist evoke a carnival-like atmosphere, perhaps of the midway, perhaps of an entertainment mecca like Times Square.

The abstract use of color plays a significant role in the work of the artist Jonathan Lewis, as seen in his *Composition in Red, Yellow, and Blue (Mondrian)*. In his print *Dr Toms Eucalyptus* (fig. 45) from the series *See Candy*, the color arrangement and pattern attract the viewer's attention. However, it is not just the finished product but also the inspiration and process that link *Dr Toms Eucalyptus* and other works in the series to Neo-Impressionism. As Norma Broude and others have argued, many of the Neo-Impressionists were interested in contemporary printmaking techniques, particularly new advances in color printmaking.[7] Signac, Luce, Camille and Lucien Pissarro, and other Neo-Impressionists all made prints, and many began to experiment with color printmaking as those techniques developed through the 1890s and beyond. Some of the Neo-Impressionists, including Luce and Lucien Pissarro, also worked as printmakers, a logical day job for aspiring young painters. When he began work on the *See Candy* series, Lewis was also employed as a printmaker, and, like the Neo-Impressionists, he was working with the latest in printmaking technology—digital fine-art printmaking. Lewis worked with the IRIS printer, a high-quality, large-format inkjet printer used extensively for fine-art printmaking. The images in the *See Candy* series were inspired by an accident. Normally, to produce an IRIS print, software converts the color information in an image so that it can be printed using the four-color process of the IRIS. Occasionally, the conversion process misfires and only a limited amount of information is directed to the printer. Essentially, the printer gets stuck on just a few areas of color in the image it is producing and repeats them endlessly down the paper, producing vertical stripes. Lewis admired the accidental effects produced by these printing mistakes and found a way to replicate them by scanning a candy wrapper, selecting and digitally repeating the signal colors in the wrapper to produce the desired color pattern. Ironically, these finished prints are produced on the IRIS—the same printer whose mistakes formed the inspiration for Lewis's images.

In Lewis's work the malfunctions of technology provided the impetus for artistic creation, and the same technology was employed to realize the finished artwork. As mentioned, that the technology in question is a digital form of printmaking invites a comparison with the work of the Neo-Impressionists. However, not only Lewis's work but the work of all the artists featured in this essay was produced, at least in part, on the IRIS printer. The significance of printmaking and its status as a new technology deserve

Fig. 45.
Jonathan Lewis, *Dr Toms Eucalyptus*, from the series *See Candy*, 2000, IRIS print, 33 x 33 inches, Courtesy of Silicon Gallery Fine Art Prints

to be considered further in regard to the Neo-Impressionists and to digital artists. Although an extensive consideration of this connection is beyond the scope of this essay, a few examples may begin to illustrate points of contact and critical themes.

Printmaking enjoyed a renaissance in popularity in late-nineteenth-century Paris, as sophisticated and efficient print workshops turned out illustrations for such magazines as *Paris Illustré* and *L'Illustration*.[8] The majority of these printed illustrations were produced using lithography, which had taken the print industry by storm in the early 1800s and was ideally suited for the mass production of images.[9] The very popularity of lithography and its associations with mass-produced publications led many artists away from the medium by midcentury. However, the development of color lithography in the 1880s and its perfection in the 1890s brought many painters, including some of the Neo-Impressionists, back to the medium.[10]

To produce color lithographs, an image was separated into color groups, with one set of colors inked on each lithographic stone and then transferred to the paper. The master printmaker bore the responsibility for creating these color separations, though the artist would generally oversee production and approve proofs of the image before the final print run. That process of collaboration between printmaker and artist was a critical one, and a breakdown in communication between the two could lead to disastrous results. An example of an artist whose experiments with color lithography were largely successful was Signac, whose "systematic method of painting in dots was particularly well suited to collaborative printmaking, since his precise division of pigments allowed easy sorting into color groups by the printer for the requisite number of lithographic stones."[11] One of Signac's color lithographs, *Application of the Chromatic Circle of Mr. Charles Henry*, in fact illustrated the basic principles of the color theory promoted by Henry and utilized by Signac and the other Neo-Impressionists in their works (see fig. 38).[12] Despite its importance as something of a manifesto, this commercial lithograph was cheaply produced, printed on the back of a theater program. The pairing of pigmentary opposites (red-green, blue-orange, yellow-violet) is evidenced throughout the image, but particularly in the tondo, which "is filled with contrasting colors. At the top, the orange-red of the

stage is opposed by the bluish green of the spectator's hair; in the middle, the yellow of the footlights sets off the purple hair; and lower down the hair is bluish green again to oppose the ruddy flesh tones."[13]

For Signac, the color lithograph afforded him a way to capture the color effects of his paintings in an inexpensive and easily reproducible form. For the photographer Thomas Brummett, the IRIS print allows him to replicate the effects of the darkroom on a scale that could not be achieved by traditional means. Brummett creates his ethereal images, such as *Lotus Pod #3* (fig. 46), by manipulating the photographic plate during the printing process to produce a one-of-a-kind silver print. Once he has fixed an image, however, it can no longer be reproduced by photographic means; that is, no additional photographic prints can be made of the image. The image is also captured in 8-by-10-inch format and, because it is a unique image, cannot be enlarged in the darkroom. By collaborating with a digital fine-art printmaking studio, Silicon Gallery Fine Art Prints, Brummett is able to create greatly enlarged images of his prints in small editions. The images are scanned into a computer for enlarging and then output at 30 by 30 inches on the IRIS printer. The resulting large-scale prints retain the hand-worked quality of the initial images, a quality achieved in part by the collaborative nature of the digital printmaking process. Like Signac, Brummett entrusts the digital printmaker with the setup of his images but works closely with the printmaker during the proofing and production stages to make sure that the finished product meets his aesthetic criteria. Fittingly, Brummett's print bears a stylistic resemblance to *Village d'Île-de-France* (fig. 47) by Lucien Pissarro (1863–1944), who himself worked as a printmaker and whose father, Camille, made many prints during the last decades of the nineteenth century.[14] Lucien's painting, with its limited tonal range and pronounced stipple effect, reflects qualities of his father's etchings and aquatints from the 1870s. Likewise, Brummett's print also uses a restrained palette, and its stippled surface adds to the quality of otherworldliness with which the simple subject is imbued.

In tone and palette, Georges Seurat's painting *Harbour and Quays at Port-en-Bessin* of 1888 (see fig. 2) also shares the muted quality of Brummett's image. Seurat is considered the progenitor of the Neo-Impressionist movement, though his early death left Signac to become the movement's most ardent spokesman. Although Seurat's death in 1891 predated the heyday of color lithography in the 1890s, Broude argues successfully for his interest in an earlier and more primitive form of color printmaking, *chromotypogravure*, and for parallels between that process and the methods and visual problems Seurat explored.[15] Throughout the 1880s, various forms of *chromotypogravure* were employed to print colored illustrations with modeled forms and hues of varying intensity. For the most part, these effects were achieved by overlaying photoengraved line drawings, which provided the modeling, with screened or grained colorplates, which provided the hues. These early attempts used only a limited number of colors and obtained their effects through the adjacent placement of those colors. Beginning in 1885, however, the magazine *L'Illustration*, as Broude recounts:

Fig. 46.
Thomas Brummett, *Lotus Pod
#3*, 1996, IRIS print on
Somerset paper, 30 x 30 inches,
Courtesy of Silicon Gallery
Fine Art Prints

Fig. 47.
Lucien Pissarro, *Village d'Île-de-France*, 1889, oil on canvas, 15⅜ x 20¼ inches, Walter F. Brown Collection

published a series of photo-engraved, color supplements of unprecedented complexity and sophistication in which the forms are no longer simply tinted with a local color, but skillfully modeled by virtue of both the overlapping and the optical mixture of an extraordinary number of speckled hues. . . . Mass-produced specially for the readers of *L'Illustration*, these examples of the photo-engraver's art are of extremely high quality for the period. Pulled from grained, relief-etched plates, they present granulated surfaces that are remarkably similar in their appearance and abstract textural consistency to those displayed by Seurat's pictures after the artist's adoption of a pointillist mode of execution at approximately this same time.[16]

Broude goes on to suggest that Seurat's optical modeling effects were achieved by his using a process similar to that employed in *chromotypogravure*, by using hues beyond the pigmentary primaries, juxtaposing them carefully, and manipulating their intensity to create the sense of volume and luminous surface-play apparent in Seurat's images. Seurat's acknowledged interests in popular and commercial art forms and his association with artists such as Lucien Pissarro, whose connection to the art of printmaking has already been noted, provide a basis for that conclusion. Thus, it seems reasonable to assume that, in addition to a connection with the scientific theories of the day, the style of the Neo-Impressionists was also founded, at least in part, on an interest in mechanical and commercial art-making processes. That final connection leads us to the work of the contemporary photographer Ruth Thorne-Thomson, whose images rely for their creation on mechanical processes both old and new.

Thorne-Thomson's black-and-white prints, such as *Small Dog* (fig. 48), share with the work of Brummett a soft and misty quality that can also be connected to the art of some Neo-Impressionist painters. In its form, Thorne-Thomson's image also reflects another nineteenth-century artistic and commercial practice—photography and particularly the stereograph.[17] The stereographic image was a popular entertainment item in the late nineteenth century, and the rounded form of Thorne-Thomson's print reads as one half of a stereographic pair. Likewise, the unusual and intriguing landscapes presented in such images as *Small Dog* call to mind the exotic travelscapes popular in stereographic imagery. To create her prints, Thorne-Thomson even utilizes a nineteenth-century technology, the pinhole camera, to capture the initial image. Then, however, the twentieth-century technology of the computer provides the means to realize the artist's vision. For the surreal quality of the landscapes is no accident—these are not real places but manipulated versions of original photographic images, whose scale, color, and form are distorted to create a new landscape extant only in the imagination of the artist and, ultimately, of the viewer. Thorne-Thomson again uses the IRIS printer to output the final product, using sepia tones and a watercolor paper that again suggest the nineteenth-century origins of these works and that obscure their contemporary manipulation. As was

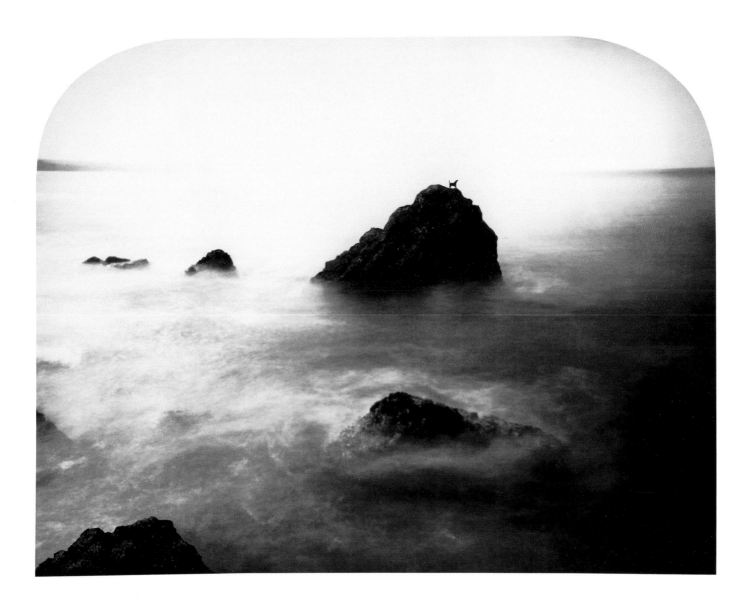

Fig. 48.
Ruth Thorne-Thomson, *Small Dog*, 2001, IRIS print, 23 x 36 inches, Courtesy of Silicon Gallery Fine Art Prints

the case for Seurat, mechanical and commercial processes are called into service in the production of Thorne-Thomson's works of art.

Artists use tools to realize their creative vision. Those tools have varied and evolved through the ages, and the introduction of new processes typically meets with resistance from some elements of the art establishment. The Neo-Impressionists introduced the new tools of color theory and color printmaking in the service of their artistic practice and received their share of both criticism and praise. Digital artists have introduced the computer and digital printer as tools to realize their creative vision and likewise have encountered both positive and negative responses from the contemporary art world. Neo-Impressionism has weathered its criticism to retain a place within the formative movements of modern art; the critical and historical fate of contemporary digital artists remains to be seen. However, recognition of the ties that bind such seemingly disparate movements together help to increase our understanding and appreciation of both styles and of the artists who created them.

Notes

1. Robert Herbert, *Neo-Impressionism* (New York: Guggenheim Foundation, 1968), p. 14.

2. It should be noted, of course, that modernist artists from Marcel Duchamp forward have also called into question the role of craft or workmanship in artistic production through the creation of "readymades," conceptual and performance artworks, and other forms of mechanically assisted art (such as video and installation art). The relation of digital art to the machine is linked to these earlier means of production while at the same time raising new questions.

3. A fractal is an endlessly repeating geometric form. Fractals occur naturally in crystals, plants, shells, and many other organic materials. Because their repetitive forms can be analyzed mathematically, they can be digitally generated by software programs.

4. Félix Fénéon, "L'Impressionnisme aux Tuileries," *L'Art moderne*, September 19, 1886, translated and quoted in William Innes Homer, *Seurat and the Science of Painting* (Cambridge, Mass.: The MIT Press, 1964), p. 237. Ogden Rood's 1881 treatise, *Modern Chromatics*, was of great interest to Seurat, the painter of *A Sunday on La Grande Jatte–1884* (fig. 49), and to other Neo-Impressionist artists.

5. Floyd Ratliff, *Paul Signac and Color in Neo-Impressionism* (New York: The Rockefeller University Press, 1992), p. 262.

6. Ellen Wardwell Lee, *The Aura of Neo-Impressionism: The W. J. Holliday Collection*, exh. cat. (Indianapolis: Indianapolis Museum of Art, 1983), p. 18.

7. Norma Broude, "New Light on Seurat's 'Dot': Its Relation to Photo-Mechanical Color Printing in France in the 1880's," in *Seurat in Perspective*, ed. Broude (Englewood Cliffs, N.J.: Prentice-Hall, Inc., 1978), pp. 163–75.

8. For a discussion of the revival of printmaking in Paris in the nineteenth century and its effects on Impressionist and Neo-Impressionist painters, see *French Printmakers of the Nineteenth Century: Selected Works from the Collection of the Art Gallery of Ontario*, exh. cat. (Toronto: Art Gallery of Ontario, 1973); John Ittman, *Post-Impressionist Prints: Paris in the 1890s*, exh. cat. (Philadelphia: Philadelphia Museum of Art, 1998); and Antonia Lant, "Purpose and Practice in French Avant-Garde Print-making of the 1880s," *The Oxford Art Journal* 6, no. 1 (1983): 18–29.

9. Ittman, 1998, p. 12.

10. Ittman, 1998, pp. 13–16.

11. Ittman, 1998, p. 48.

12. Ittman, 1998, p. 49.

13. Ratliff, 1992, p. 12.

14. Lucien Pissarro's work as a printmaker and his affiliation with Seurat are discussed in Broude, 1978, pp. 173–74. Camille Pissarro's prints are examined extensively in Lant, 1983.

15. Broude's (1978) extensive discussion of the developments in printmaking during the 1880s is instructive not only for an understanding of Seurat's work but also for the connections between technology and artistic practice generally, which form the basis of this essay.

16. Broude, 1978, pp. 168–69.

17. Stereographs are paired images meant to be viewed simultaneously through a device called a stereoscope. This simultaneous viewing of two nearly identical images induces the optical illusion of depth within a single image.

Exhibition Checklist

Artists are listed alphabetically and their works chronologically. Measurements are in inches, height preceding width. Number in parentheses with entry refers to the page on which the work is illustrated.

Johannes Josephus Aarts
Holland, 1871–1934
Farm "De Bataaf," 1895
Oil on canvas, 12⅝ x 18⅛
Lent by The Gemeentemuseum
Den Haag, The Hague,
The Netherlands

Hendrik Pieter Bremmer
Holland, 1871–1956
Paysage avec maisons (*Landscape with Houses*), circa 1898 (p. 24)
Oil on canvas, 16½ x 22
Walter F. Brown Collection

Henri-Edmond Cross
France, 1856–1910
Coast near Antibes, 1891–92 (p. 18)
Oil on canvas, 25⅝ x 36¼
National Gallery of Art,
Washington, John Hay Whitney
Collection, 1982.76.2

The Grape Harvest (Var), 1892 (p. 33)
Oil on canvas, 37⅜ x 55¼
The Museum of Modern Art, New
York, Mrs. John Hay Whitney
Bequest, 1998

Étude pour Vendanges (study for *The Grape Harvest*), circa 1892
Oil on panel, 9 x 7½
Collection of Mr. and Mrs. John
Whitney Payson

Excursion, 1895 (p. 31)
Oil on canvas, 45¾ x 64¾
Chrysler Museum of Art, Norfolk,
VA; Gift of Walter P. Chrysler, Jr.,
77.416

At the Fair, 1896 (p. 73)
Oil on canvas, 36⅜ x 25¾
Toledo Museum of Art; Purchased
with funds from the Libbey
Endowment, Gift of Edward
Drummond Libbey, 1951.308

Nursemaids on the Champs-Élysées,
1898
Color lithograph, image: 7¹⁵⁄₁₆ x 10 ⁵⁄₁₆;
sheet: 10⅜ x 14½
Museum of Fine Arts, Boston.
Bequest of W. G. Russell Allen

L'Arbre penché, ou Le Rameur
(*The Leaning Tree, or The Rower*),
circa 1905 (p. 35)
Oil on canvas, 25½ x 31⅞
Private collection

Antibes, après-midi (Antibes in the Afternoon), 1908 (p. 51)
Oil on canvas, 31⅞ x 39⅜
Scott M. Black Collection

The Little Maures Mountains, 1909 (p. 34)
Oil on canvas, 13½ x 22
Collection of The Dixon Gallery and Gardens, Memphis, Tennessee; Bequest of Mr. and Mrs. Hugo N. Dixon, 1975.17

Albert Dubois-Pillet
France, 1846–1890
Sous la lampe (Under the Lamp), circa 1888 (p. 50)
Oil on canvas, diameter 22½
University of Michigan Museum of Art, Gift of Helmut Stern

Georges Lemmen
Belgium, 1865–1916
The Little Boy (Le Garçonnet), 1900
Lithograph printed in gray-green ink, image: 12¹⁵⁄₁₆ x 14⅛; sheet: 14 x 17½
Museum of Fine Arts, Boston. Gift of Benjamin A. and Julia M. Trustman

André Léveillé
France, 1880–1962
Le Retour des moissonneurs (The Return of the Harvesters), undated (p. 70)
Oil on canvas, 15 x 20½
Walter F. Brown Collection

Maximilien Luce
France, 1858–1941
Morning, Interior, 1890 (p. 26)
Oil on canvas, 25½ x 31⅞
The Metropolitan Museum of Art, New York, Bequest of Miss Adelaide Milton de Groot (1876–1967), 1967 (67.187.80)

Port of London, Night (Port de Londres, La Nuit), 1894 (p. 27)
Oil on canvas, 28 x 35¼
High Museum of Art, Atlanta, Georgia; Gift in memory of Caroline Massell Selig (1919–1984), 1985.22

Camaret, la digue (The Breakwater at Camaret), 1895 (p. 5)
Oil on canvas, 25⅝ x 36¼
Scott M. Black Collection

Portrait of a Boy, 1895 (p. 27)
Oil on canvas, 21 x 18¼
Centennial gift of Mrs. Toivo Laminan (Margaret Chamberlin, Class of 1929), Davis Museum and Cultural Center, Wellesley College, Wellesley, MA, 1976.19

Usines de Charleroi (Blast Furnaces), 1895
Series title: Pan
Color lithograph on paper, sheet: 14½ x 11¹⁄₁₆
Fine Arts Museums of San Francisco, Museum Purchase, Achenbach Foundation for Graphic Arts Endowment Fund, 1982.1.14

The Arsonist, 1895–96 (p. 29)
Series title: Les Temps Nouveaux
Lithograph printed in black on gray-blue wove paper, mounted by artist, sheet: 15¼ x 11⅞
Courtesy of the Fogg Art Museum, Harvard University Art Museums, Deknatel Purchase Fund

Les Aciéries à Charleroi (Cheminée d'usine) (The Steelworks in Charleroi, Factory Chimney), 1896 (p. 30)
Oil on canvas, 23 x 28
Private collection

Les Cheminées d'usines, Couillet près de Charleroi (The Factory Chimneys, Couillet near Charleroi), 1898–99 (p. 30)
Oil on canvas, 28¾ x 39½
Walter F. Brown Collection

Éragny, les bords de l'Epte (Éragny, on the Banks of the Epte), 1899 (p. 57)
Oil on canvas, 32 x 45¾
Scott M. Black Collection

Henri Martin
France, 1860–1943
Le Pont, l'église et l'école de La Bastide-du-Vert (The Bridge, Church, and School of La Bastide-du-Vert), 1920 (p. 43)
Oil on canvas, 45¾ x 43¾
Walter F. Brown Collection

Jean Metzinger
France, 1883–1956
Paysage avec bateaux à voiles (Landscape with Sailboats), circa 1902 (p. 37)
Oil on canvas, 18½ x 25
Norton Museum of Art, West Palm Beach, Florida. Purchased through the R. H. Norton Fund, J. Ira and Nicki Harris Foundation, Anne and Harold Smith and Nanette Ross, 99.86

Paysage pointilliste (Pointillist Landscape), circa 1907 (p. 37)
Oil on canvas, 25¾ x 36½
Walter F. Brown Collection

Hippolyte Petitjean
France, 1854–1929
Baigneuse au bord de la rivière (Bather at the River's Edge), 1890 (p. 71)
Oil on canvas, 21⅞ x 15⅛
Walter F. Brown Collection

Landscape with a Row of Poplars, 1900–1925
Watercolor on paper, sight: 12 x 18½
Museum of Fine Arts, Boston.
Gift of Mr. A. M. Adler

Landscape, undated
Watercolor on paper, 12⅞ x 16¹³⁄₁₆
Fine Arts Museums of San Francisco, Memorial Gift from Dr. T. Edward and Tullah Hanley, Bradford, Pennsylvania, 69.30.159

Lucien Pissarro
France, 1863–1944
Village d'Île-de-France, 1889 (p. 78)
Oil on canvas, 15⅜ x 20¼
Walter F. Brown Collection

Théo van Rysselberghe
Belgium, 1862–1926
Anna Boch, circa 1889 (p. 20)
Oil on canvas, 37⅜ x 25⅝
Museum of Fine Arts, Springfield, Massachusetts, James Philip Gray Collection, 70.04

The Port of Sète (Le Port de Cette), 1892 (p. 49)
Oil on canvas, 21½ x 26
The Museum of Modern Art, New York, Estate of John Hay Whitney, 1983

La Régate (The Regatta), 1892 (p. 46)
Oil on canvas with painted wood liner, 23⅞ x 31¾
Scott M. Black Collection

Big Clouds (Gros nuages), 1893 (p. 21)
Oil on canvas, 19½ x 23½
Indianapolis Museum of Art, The Holliday Collection, 79.287

Fleet of Fishing Boats, 1894
Etching and aquatint, printed in brown ink on beige paper, platemark: 8¹³⁄₁₆ x 11⅛; sheet: 9⁵⁄₁₆ x 12⁵⁄₁₆
Museum of Fine Arts, Boston.
Gift of Mr. and Mrs. Peter A. Wick

*Poster for N. Lembrée, Estampes
& Encadrements . . . Brussels*, 1897
Color lithograph on wove paper,
sheet: 27⅜ x 20⅛
Museum of Fine Arts, Boston.
Gift of Azita Bina-Seibel and
Elmar W. Seibel

Bateaux de pêche (Fishing Boats),
undated
Etching and aquatint on paper,
8¾ x 11¹¹⁄₁₆
Fine Arts Museums of San
Francisco, Achenbach Foundation
for Graphic Arts, 1963.30.1331

Claude-Émile Schuffenecker
France, 1851–1934
*Maison bretonne dominant la mer
(Breton House Overlooking the Sea)*,
1886 (p. 13)
Oil on canvas, 19⅞ x 24¼
Walter F. Brown Collection

Georges Seurat
France, 1859–1891
Harbour and Quays at Port-en-Bessin,
1888 (p. 6)
Oil on canvas, 26 x 32¾
Lent by The Minneapolis Institute
of Arts, The William Hood
Dunwoody Fund

Seascape at Port-en-Bessin, Normandy,
1888 (p. 10)
Oil on canvas, 25⅝ x 31⅞
National Gallery of Art,
Washington, Gift of the W. Averell
Harriman Foundation in memory of
Marie N. Harriman, 1972.9.21

Woman Seated by an Easel, circa
1884–88
Black chalk on cream wove paper,
12 x 9³⁄₁₆
Courtesy of the Fogg Art Museum,
Harvard University Art Museums,
Bequest from the Collection of
Maurice Wertheim, Class of 1906

The Barge, undated
Conté crayon on cream wove paper,
9⁷⁄₁₆ x 12³⁄₁₆
Courtesy of the Fogg Art Museum,
Harvard University Art Museums,
Gift of Therese Kuhn Straus in
memory of her husband, Herbert N.
Straus, Harvard Class of 1903

Paul Signac
France, 1863–1935
*Application of the Chromatic Circle of
Mr. Charles Henry*, 1888 (p. 66)
Lithograph, 6 x 7
Courtesy of the Fogg Art Museum,
Harvard University Art Museums,
Anonymous Loan in honor of
Virginia H. Deknatel

View of the Seine at Herblay, Opus 203
late 1880s (p. 13)
Oil on canvas, 13⅛ x 18¼
Museum of Fine Arts, Boston. Gift
of Julia Appleton Bird, 1980.367

The Jetty at Cassis, 1889 (p. 16)
Oil on canvas, 18¼ x 25⅝
The Metropolitan Museum of Art,
New York, Bequest of Joan Whitney
Payson, 1975 (1976.201.19)

Port of Saint-Cast, Opus 209, 1890
(front cover)
Oil on canvas, 26 x 32½
Museum of Fine Arts, Boston. Gift
of William A. Coolidge, 1991.584

The Stone Breakers, 1896
Lithograph, image: 16 x 12;
sheet: 20⅞ x 13⁷⁄₁₆
Museum of Fine Arts, Boston.
Anonymous gift

Entrance to the Grand Canal, Venice, 1905 (p. 39)
Oil on canvas, 29 x 36¼
Toledo Museum of Art; Purchased with funds from the Libbey Endowment, Gift of Edward Drummond Libbey, 1952.78

Port d'Antibes, 1909 (p. 40)
Oil on canvas, 21¼ x 25½
The Whitehead Collection, courtesy Achim Moeller Fine Art, New York

Antibes, le nuage rose (Antibes, the Pink Cloud), 1916 (p. 61)
Oil on canvas, 28 x 35
Scott M. Black Collection

Blessing of the Tuna Fleet at Groix, 1923
Oil on canvas, sight: 28¼ x 35½
Lent by The Minneapolis Institute of Arts, The William Hood Dunwoody Fund, the John R. Van Derlip Fund and Gift of Bernice (Mrs. John S.) Dalrymple

Petit Andely, 1924, 1924
Graphite pencil and watercolor, sheet: 11⁷⁄₁₆ x 17⅛
Museum of Fine Arts, Boston. Anonymous gift

View of Notre Dame, Paris, circa 1924
Watercolor and graphite on paper, 11³⁄₁₆ x 17⅜
Courtesy of the Fogg Art Museum, Harvard University Art Museums, Gift of Dr. and Mrs. Charles Cachin

La Rochelle, undated (p. 41)
Watercolor and conté crayon on off-white laid paper, 10¾ x 16⅞
Courtesy of the Fogg Art Museum, Harvard University Art Museums, Gift of James Naumburg Rosenberg, in memory of Aaron and Nettie Goldsmith Naumburg, on the Twenty-fifth Anniversary of the Opening of the Naumburg Wing of the Fogg Art Museum, November 8, 1957

Jan Toorop
Holland (born Java), 1858–1928
Dunes and Sea at Zoutelande, 1907 (p. 23)
Oil and pencil on cardboard on panel, 18¾ x 24⅛
Lent by The Gemeentemuseum Den Haag, The Hague, The Netherlands

Unknown Artist
France
Jeune Femme blonde au chignon (Young Woman with a Blonde Chignon), 1887–92
Oil on canvas, 17½ x 14¾
Walter F. Brown Collection

Ludovic de Vallée
France, 1864–1939
La Plage au pied de la falaise (The Beach at the Foot of the Cliff), 1924–26 (p. 44)
Oil on canvas, 37⅝ x 46⅞
Walter F. Brown Collection

Photography Credits

Achim Moeller Fine Art, New York: fig. 25.
Photographs © 2002 The Art Institute of Chicago, All Rights Reserved: figs. 33, 49.
© 2002 Artists Rights Society (ARS), New York/ADAGP, Paris: cover and figs. 1, 4, 6, 12, 13,
14, 15, 16, 17, 22, 23, 24, 25, 26, 27, 28, 35, 36, 38.
Photograph by Steve Briggs, Davis Museum and Cultural Center, Wellesley College: fig. 14.
Le Castel-Béranger, Paris, France/Giraudon/Bridgeman Art Library: fig. 37.
Courtesy of the Chrysler Museum of Art, Norfolk, Virginia: fig. 18.
The Dixon Gallery and Gardens, Memphis, Tennessee: fig. 20.
The Gemeentemuseum Den Haag, The Hague, The Netherlands: fig. 10.
High Museum of Art, Atlanta, Georgia: fig. 13.
Indianapolis Museum of Art: fig. 9.
Photographs by Katya Kallsen/© President and Fellows of Harvard College: figs. 15, 26, 38.
Photograph by Benjamin Magro: fig. 35.
Photographs by Melville D. McLean: figs. 1, 29, 32, 36.
Photographs © 1980 The Metropolitan Museum of Art: fig. 6; © 2002, fig. 12.
The Minneapolis Institute of Arts: fig. 2.
© 2000/All Rights Reserved, Museum of Fine Arts, Boston: cover; © 2001, fig. 4.
Museum of Fine Arts, Springfield, Massachusetts: fig. 8.
Photographs © 2002 The Museum of Modern Art, New York: figs. 19, 30.
Photographs © Board of Trustees, National Gallery of Art, Washington: figs. 3, 7.
Norton Museum of Art, West Palm Beach, Florida: fig. 23.
Photograph by RMN–R.G. Ojeda/Réunion des Musées Nationaux/Art Resource, New York: fig. 34.
Toledo Museum of Art: figs. 24, 44.
Photographs by Steven Tucker: figs. 5, 11, 17, 22, 27, 28, 41, 42, 47.
© The University of Michigan Museum of Art: fig. 31.

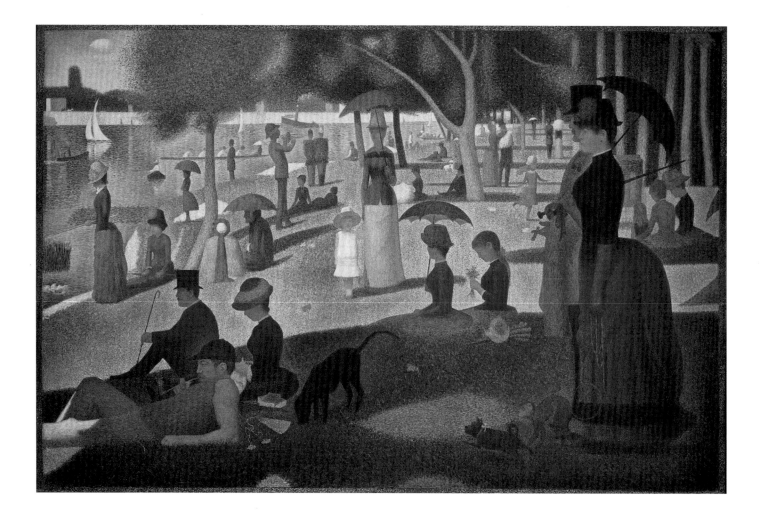

Fig. 49.
Georges Seurat (France, 1859–
1891), *A Sunday on La Grande
Jatte–1884*, 1884–86, oil on
canvas, 81¾ x 121¼ inches,
The Art Institute of Chicago,
Helen Birch Bartlett Memorial
Collection, 1926.224